Hajo Düchting

Paul Klee

Prestel

Munich · Berlin · London · New York

Inhalt

Context

"I liked only what
I was not allowed to do.
Drawing and writing.
... In Munich,
I began to paint."

Paul Klee, March 1912

The Bavarian Metropolis

By 1900, Munich's reputation as an art city was second only to that of Paris. In Munich, both traditional art and the latest styles flourished. The prevailing atmosphere, one of exuberant enthusiasm and confidence, attracted artists from around the world.

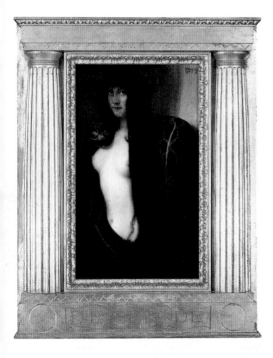

Franz von Stuck's *The Sin* (1893) caused a stir not only with its content. In stylistic terms as well, the "prince of artists" deviated from academic tradition, even if less radically than Kandinsky and Klee would do soon after.

The Munich Art Academy

Official art training at the time was academic. Strict verisimilitude and accurate, objective rendering were required. Training included drawing from life and from casts of classical sculptures. Only after long years of learning graphic skills could a pupil change to a painting class, where finally he would learn how to paint—and where the syllabus was likewise strictly academic.

Around 1900 …

→ …art was solely for men. Women were not admitted to the Academy.

→ …besides the Academy, however, there were numerous art schools that accepted pupils of either sex, provided they could pay.

SiMPLiCiSSiMUS

Preis 20 Pfg.

Illustrierte Wochenschrift

Die afrikanische Gefahr

The Prince Regent Period

Externally, the Prince Regent period—named after Luitpold, Prince Regent of Bavaria (1886–1912)—was placid. But around the turn of the century, the divisions between conservatism and the forces for change made themselves felt in art. Periodicals such as *Jugend* and *Simplicissimus* demanded a liberal attitude to religion, culture, sexuality, and the state to replace the strict laws of morality and political acquiescence. Founded by Albert Langen in 1896, *Simplicissimus* used satire to attack political and social conditions not only in Bavaria. The spirit of revolt was also blowing through the theater (the plays of Frank Wedekind and Ludwig Thoma, for example, both critical of middle-class values), but it was most conspicuous in the newly founded political cabaret Die Elf Scharfrichter (The Eleven Executioners), which was a source of inspiration to Kandinsky and others.

Bohemian Schwabing

Around 1900, the Academy and its institutions inevitably attracted artistic bohemians, who tended to congregate in a small suburb called Schwabing. Rents were low, and the numerous bars and cafés were full of young artists from all around the world. Armed with portfolios and easels, they would wander through the streets looking for subjects and dreaming of fame.

A Prince of Art

Official painting in Munich was as pretentious and conservative as Bavarian politics. An artist who lived in splendor was Franz von Stuck. His villa outside the gates of Munich was a regular meeting place for boisterous gatherings of artists (below: the Music room). Artists of this rank were considered "legislators," and not infrequently used their power to the disadvantage of young artists they did not like.

Indecent Art

In his story *Gladius Dei* (1902), the German novelist Thomas Mann provides a satirical description of brilliant but also very "comfortable" and very conservative Munich of those years, when self-appointed guardians of morality felt compelled to interfere even in art. This is illustrated in the story by his monk-like artist Hieronymus, who demands the removal of a picture from a dealer's shop window, claiming it is obscene. Here, Mann was using a real case: on the orders of the police, a photograph of Franz von Stuck's *Kiss of the Sphinx* (page 94) was removed from the window of a Munich art dealer's because it was considered indecent. "Art flourishes, art rules the day, art waves its rose-entwined scepter over the city and smiles. ... Munich is resplendent."
Thomas Mann

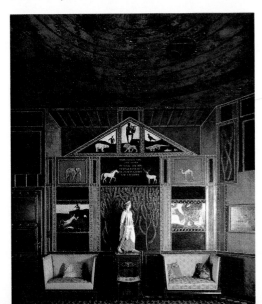

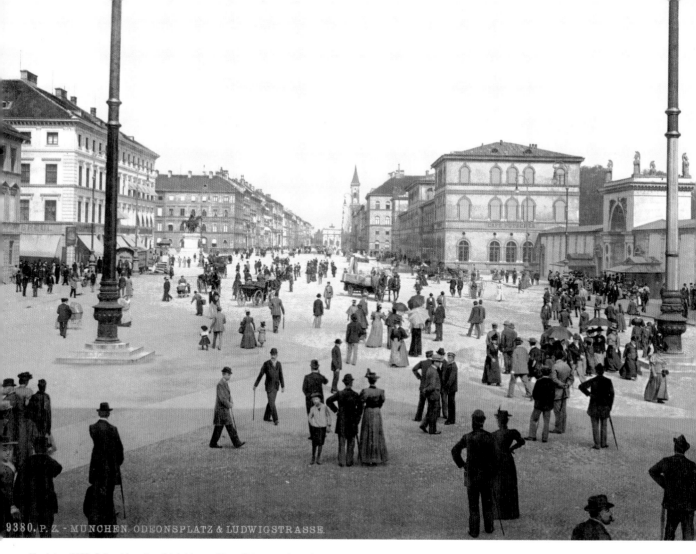

9380. P. Z. - MÜNCHEN. ODEONSPLATZ & LUDWIGSTRASSE.

Munich c. 1900: Schwabing, the district favored by artists, extends each side of the grand street Leopoldstrasse-Ludwigstrasse, which terminates in Odeonsplatz in the south.

In the early years of the 20th century, the Munich Academy of Fine Arts was considered one of the leading teaching academies in Europe.

Resplendent Munich

The young Paul Klee was also drawn to Munich, the art metropolis that promised so much. Inexperienced and meticulous, he opted for the slow, gradual path, ensuring first that he had a firm foundation in drawing. After years of study, he had become so proficient that he was well known even among modern artists in Munich.

Art in Munich Around 1900

With money from his father, Klee initially applied to the Munich Academy, but they turned him down and referred him to the numerous private art schools. Klee's real training began at Heinrich Knirr's art school, though he had already tried his hand at drawing during his school days—little more than schoolboy doodles, rather than a serious attempt at art, though Klee later included some of them in his personal catalogue of works. At Knirr's he mainly drew nudes, which at the time were the entrée to the academic art world for any prospective artist. Official taste in art was governed largely by the formal style of

"Go! Make the most of this time off for a change of air and viewpoint and find yourself transplanted into a world that as a distraction offers a shot in the arm for the inevitable return to the grayness of the working day."

Paul Klee,
Creative Credo,
1920

Even Klee found himself having
to undergo the discipline of
doing nudes in life classes,
though he soon found a very
individual treatment for them.

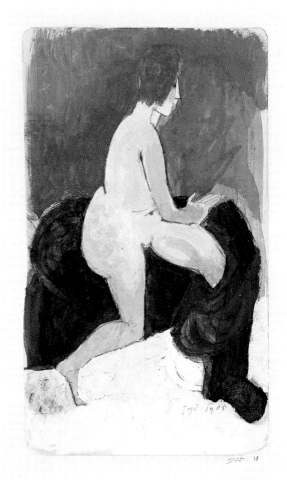

the Academy, which focused on history subjects and elegant portraits.

The Growth of Modernism

In 1892, a number of Munich artists set up the Munich Secession as a way of avoiding the rigid formalism of the academic style, and in protest against the preference given to academic artists in the art shows. The Secession acted as a rallying point for all the artists who could not gain a foothold in the art scene as a result of Prince Regent Luitpold's conservative art policy. They included the representatives of open-air painting, in other words Impressionist landscape painters, and their idealist counterparts, the artists of Symbolism and Art Nouveau. The Secession was soon an established component of the Munich art scene, and achieved some real triumphs in its annual exhibitions in a specially designed exhibition hall. The emblem Franz von Stuck designed for the hall was the head of the Greek goddess Athene (page 7), patroness of the arts and sciences. This still features

as a logo on posters, publications and exhibitions of the Secession (page 11), which became one of the most important artist groupings in Germany.

The Arts and Crafts Movement

The Munich Secession was the forerunner of another movement that developed around the turn of the century, Arts and Crafts, which sought to revive artistry in craftwork. In the summer of 1898, a special exhibition organized by the newly founded Vereinigte Werkstätten für Kunst im Handwerk (United Workshops for Art in Crafts) introduced some of the new Arts and Crafts products. On show were embroi-

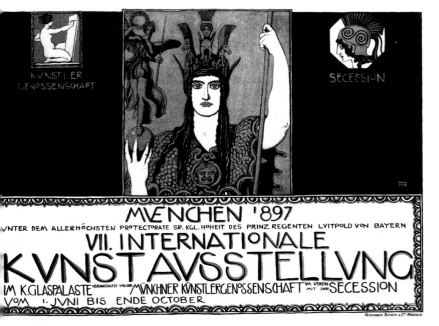

In 1897, Franz von Stuck designed the poster for the 7th International Art Exhibition in Munich.

scene acquired a new artist with an unequivocally modern orientation. With his academic background and talent for organization, he soon became a fixed star in the avant-garde firmament. His Phalanx artists' group founded in 1902 vied with the Secession by putting on 12 solo or group exhibitions of prominent modern artists. The styles ranged from Impressionism via Art Nouveau to Symbolism and Neo-Impressionism, the artists from Lovis Corinth and Claude Monet to Paul Signac, Félix Vallotton, and Henri de Toulouse-Lautrec. After the gallery and school closed, the artists met up in the drawing room of painter Marianne Werefkin in Giselastrasse to discuss art, and from these informal meetings emerged the Neue Künstlervereinigung München (NKVM: New Artists' Association of Munich) in 1909. The NKVM went public in the same year with an exhibition at the Galerie Thannhauser, which attracted vociferous condemnation from the press. The

dery by Hermann Obrist, woven wall hangings by Otto Eckmann, stained glass windows by Carl Ule, carpets by Georges Lemmen, and furniture by Bernhard Pankok and Richard Riemerschmid. Klee described this exhibition as outstanding: "The Secession is particularly great this time. Herterich, Uhde, Zorn ... as painters, and Stuck and Hildebrand as sculptors are simply astonishing. The show at the Glaspalast has not been this impressive for years. It was truly worthy of the Secession."

New Artist Groups

With the arrival of Wassily Kandinsky, the Munich art

following, for example, was in the *Münchner Neueste Nachrichten*'s review: "The whole thing looks like a wild parody or grotesque carnival joke. ... There are wonderful recipes here for anyone who, though with no shred of talent, wants to show something."

However, the NKVM was itself also soon split by sharp disagreements, and in 1911 this led to the departure of Kandinsky, Gabriele Münter, and their new comrade Franz Marc. In that year, Kandinsky and Marc put on a general exhibition of modernist art styles at the Galerie Thannhauser called *Der Blaue Reiter* (The Blue Rider). The following year, Munich publisher Piper Verlag issued an accompanying "almanac," which contained not only programmatic essays by Kandinsky, Marc, and August Macke, but also various contributions on cultural life as a whole—including the art of East Asia and Egypt, folk art, children's art, and Early German art—as diverse manifestations of artistic expression.

Klee's Years of Apprenticeship

It was against this backdrop of great turmoil in the Munich art scene that Klee got down to serious work drawing. He lived quietly in Schwabing, not far from Kandinsky, though the two of them were not acquainted at the time. In October 1900 he enrolled for Franz von Stuck's painting classes, where Kandinsky was also a student. But even there they didn't meet, for Klee mostly kept away from the

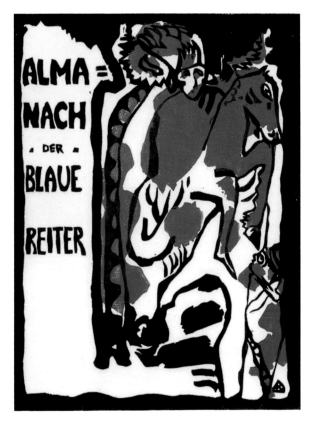

On the cover of the *Blaue Reiter* almanac, St George engages with the Dragon, a symbol of the struggle of the spirit against dull materialism.

Academy. Although Klee depicts Stuck as a stimulating and well-meaning teacher, academic instruction had nothing to offer him. He left the painting class in March 1901 and tried to enroll for sculpture, but failed. In the summer of 1901, he and fellow student Hermann Haller set off for Italy for several months. Klee studied Old Masters in Rome, where the two men spent most of their time, but also sketched and played music. In May 1902 he returned to Bern, where, living with his parents for several years, he developed his artistic skills by himself.

In July 1903 he started work on a series of etchings called *Inventions* (page 15 and 21), unconventional works that combine virtuoso graphic techniques with sarcastic humor. A fortnight in Paris introduced him to many artists and groups, notably the Impressionists, but not their modernist successors, Paul Cézanne and Henri Matisse.

In September 1906, Klee married pianist Lily Stumpf in Bern, and on 1 October they moved into a small flat in Schwabing. Lily gave piano lessons, while Klee painted and ran the household. His attempts to make a go of art had so far all failed.

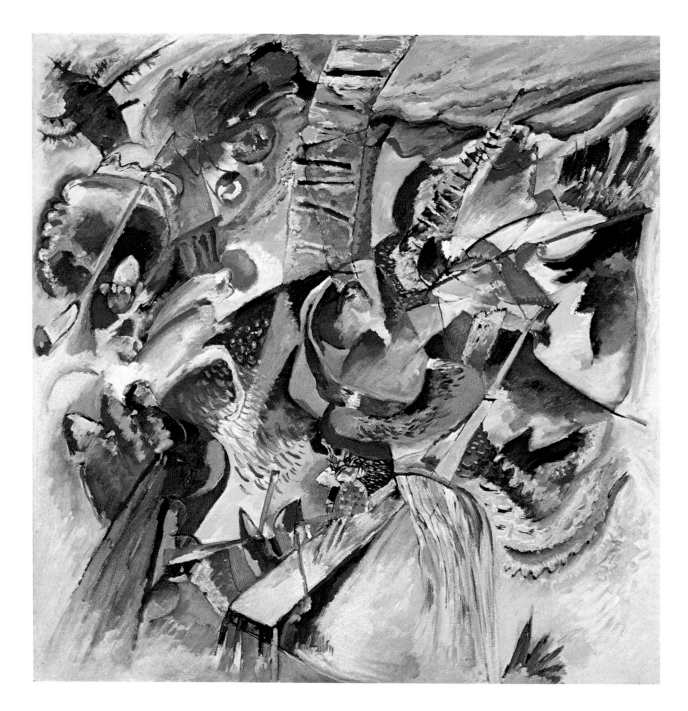

Idyll in chaos Amid the chaos of colors and shapes an idyllic scene is hidden away: a couple in Bavarian costume on a landing stage. Kandinsky sets the expected apocalypse in the middle of his beloved Bavaria. But the Jacob's Ladder leading out of the picture promises salvation from doom.

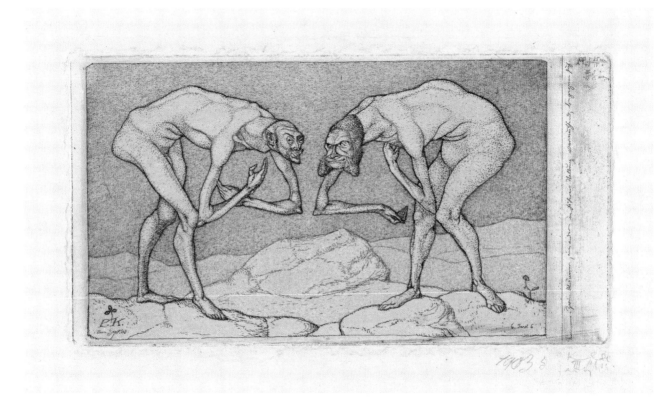

Remarkable kowtow *Two Men Meet, Each Believing the Other to Be of Higher Rank* comes from a folder of eleven etchings called *Inventions* that Klee began in July 1903 and concluded in spring 1905.

Fame

"Klee was someone with deep wisdom and astonishing knowledge. A timeless man of indeterminate age but one to whom, like an attentively alert child, all experiences of the senses of sight and sound, touch and taste, were eternally captivating and new."

Lyonel Feininger (above) on Paul Klee

Art as an allegory of Creation ...

... was for Klee the driving force behind his artistic output. His works make Creation visible in miraculous and diverse ways. They show the magic of things as they evolve. Klee saw the world as a constant process of renewal, a coherent whole full of movement and vitality.

View of Klee's studio in Schlösschen Suresnes, Munich.

Klee's *Creative Credo*

All his life, Klee wrote very detailed accounts of his thoughts and actions. His extensive correspondence with his family, friends and fellow artists, together with his carefully edited diary entries, which were intended to project a specific artistic image, all bear this out, as do his theoretical writings, which are still not fully researched. One of Klee's most important written statements of his artistic beliefs is his *Schöpferische Konfession* (Creative Credo), which was published in a collection of writings edited by Kasimir Edschmid in 1920. The following passage is one of the most important things Klee said, because it throws light programmatically on his attitude as an artist: "In the past, we depicted things that were to be seen on Earth, that we were glad to see or would like to have seen. Now the relativity of visible things is revealed, therewith giving expression to the belief that visible things are only isolated examples in the universe, and that many other truths lie hidden. Things appear in expanded, manifold senses, often apparently contradicting the rational experiences of yesterday. ... All energy requires a complement to bring about a self-contained state located above the play of forces. In the end, a formal cosmos made up of abstract formal elements is created—over and beyond their combination into tangible beings or abstract things such as numbers and letters—that manifests such similarity to the great Creation that a breath is enough to turn the expression of religiousness or religion into fact."

Futurist painter Umberto Boccioni attempted to depict movement and emotions in his works. Left: *States of Mind I: The Fare-wells* of 1911.

A Dynamic World

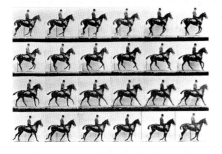

Impressionism and its successor styles had set the whole world in motion. Henceforth, artists were inspired as much by the newly discovered laws of nature as by theories of art and philosophy. Cubism sought to render three-dimensionality and volume on flat surfaces, and in doing so discovered the simultaneous multiple aspects of things. Some critics interpreted that as a quest for a fourth dimension in pictures, i.e. time, while others spoke of simultaneity as a philosophical problem. The Futurists were particularly fascinated by science, especially electro-magnetic waves, X-rays, and atomic theory—in other words by the way energy permeates all matter. Their paintings and sculptures look as if shattered into fragments by invisible but powerful rays of cosmic energy. The demateri-alization of the world into currents and rays, vibrations, oscillations and waves, was presented as a new conception of the universe, and was greeted with enthusiasm.

In philosophy and literature, a "cult of life" prevailed that saw life as a dynamic process. Photography sought to record sequences of move-ments in serial images, so as to be able to study the phenomenon of motion better (Eadweard J. Muybridge, see photo above, and E. J. Marey). The discoveries and inventions of science and technology, from radio to auto-mobiles, confirmed that the age of movement and change had arrived.

Dialogue with Nature

Klee decided early on that he could never become an artist unless he made a close study of nature. But he did not think that that meant replicating things or people as accurately as possible, as the Academy in Munich wanted; it meant cautiously groping his way to-wards the "innermost secrets of life." In the process, every-thing interested him, the whole spectrum of life, ran-ging from small, seemingly insignificant things such as stones, feathers, leaves, bal-loons, and implements of all kinds, which he studied closely, to cosmic events whose scientific discovery he followed attentively. Biology, chemistry, physics, botany, and astronomy, all fascinated him. For his art, Klee sought first to comprehend every-thing and then to set it in a living context.

After his trip to Tunis in 1914, Klee endeavored to transfer his new abstract style into oils. The oil painting *Carpet of Memory* (1914) was done shortly prior to the outbreak of World War I, and shows abstract symbols being linked with landscape.

Aged Phoenix comes from a series of 11 etchings called *Inventions*, finished by Klee in spring 1905.

The Magician of Painting

Unlike other modern painters such as Wassily Kandinsky, Piet Mondrian and Kasimir Malevich, Klee did not seek to create an abstract, non-representational world. His artistic vision encompassed the whole of life, but not in a naturalistic, purely external portrayal. It involved an expanded perception that penetrated to the heart of life.

The Study of Nature

Klee's career as a professional artist began relatively late—in fact, only in the war years of 1914–1918 when he was in his late thirties did his artistic output increasingly find admirers. But even in his apprentice years in Munich, he set himself the aim of "arranging movement over and above pathos." Movement was for him the motivating force of all creativity, the secret source of life to which all laws and creative processes were subject. So the study of nature was a *sine qua non* of achieving his aims if all these processes were to be experienced. For Klee, the final work of art was a "formal cosmos" that

"Art is like an allegory of Creation. [Each work] is an example, rather in the way earthly things are examples of cosmic things."

Paul Klee,
Creative Credo, 1920

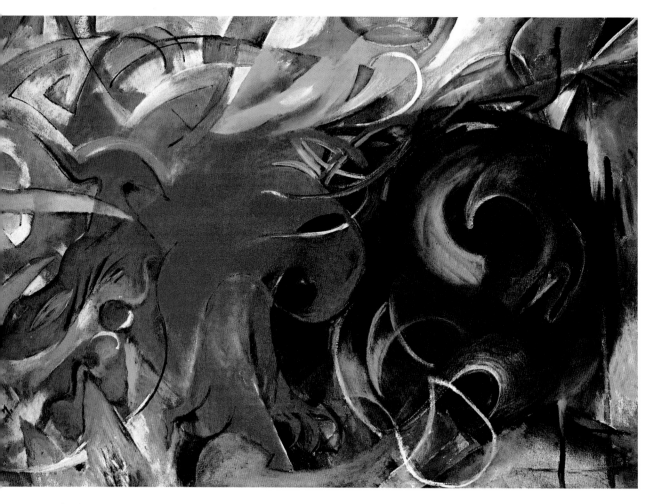

displayed eloquent similarities with Creation right down to the innermost heart of its formal relationships. Astonishingly open and alert to all things of life, he found an occasion for artistic engagement in every aspect of the world.

Art and Politics

Yet Klee was by no means an impractical dreamer who yielded only to his artistic passions. Although political attitudes towards events of his time can only be indirectly inferred from the letters and diary entries—if at all, since Klee revised his diary entries again and again in order to project a quite specific image of himself as an artist. Nevertheless, there are

sufficient comments which suggest both sympathy for revolutionary aspirations (such as his remarks on Oscar Wilde's essay on socialism, and his sympathy for the brief Soviet Republic set up in Munich in 1919) and a general rejection of exaggerated German nationalism and later also the war.

In addition, there are a number of satirical drawings that make Klee's anti-nationalistic attitude clear. The death of his friend Franz Marc near Verdun on 4 March 1916 prompted Klee to define himself by distinguishing his work from Marc's: "My art lacks a passionate kind of humanity. I love animals and all sorts of unearthly beings dearly. I neither defer to them or raise them to my level. I prefer to dissolve

left: Franz Marc's *Fighting Forms* (1914) depict the struggle between two antithetical principles, which can be interpreted both politically and philosophically.

right: In *Heavy Pathos*, Klee adopts Robert Delaunay's techniques, deftly combining them with his poetic symbolism.

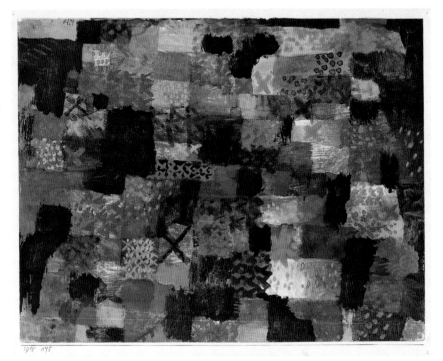

myself in the cosmos in advance and then stand fraternally on a level with my neighbor, indeed with all mortal beings. I seek a remote point where creation springs, where I feel there is one invariable formula for man, animals, plants, earth, fire, water, air and all directive forces. The Earth concept recedes before the World concept. Love is remote and religious."

These words characterize Klee as a man who had turned away from mundane affairs to devote himself entirely to his art. They constitute a program, but they do not do justice to Klee as a person, who is described by people who had personal experience of him as a sympathetic, tolerant and critically fully aware contemporary.

Klee and the Avant-Garde

Even if Klee developed his work in relative seclusion and cultivated the idea of artistic autonomy, he was by no means remote from the great artistic currents of modernism. In 1911, after completing his long, self-imposed apprenticeship, Klee finally came into contact with the artistic avant-garde. Making the acquaintance of Kandinsky and Marc, he became part of the Blauer Reiter group of artists, and contributed prints to their second exhibition in February 1912. Stimulated by these new acquaintances, who confirmed him in his search for an "inner, essential" art, in April 1912 he went to Paris and saw the latest pictures by Robert Delaunay, whose work would have

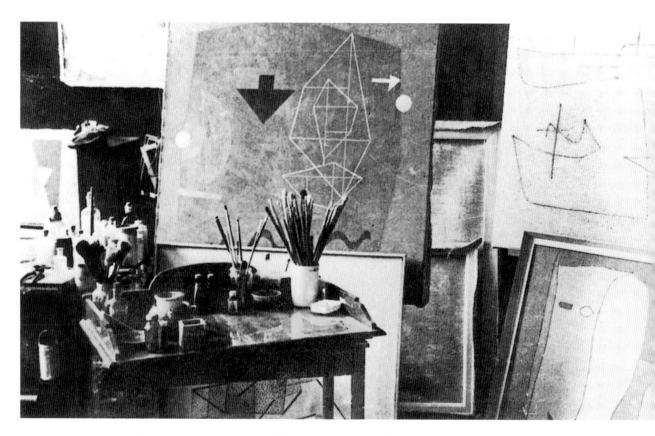

an enduring effect on his own development. In 1913, art patron Herwarth Walden exhibited Klee at his Sturm Gallery in Berlin.

As he grappled with the modern styles of Cubism and Futurism, Klee gradually developed the idea of an art that would "penetrate to the heart of things." For Klee, Robert Delaunay's genre of "window pictures" became a model for a new form of abstract composition.

For the Surrealists and the Dadaists—with their rejection of rational composition in their aversion to the horrors of war—Klee's work were a revelation. His images, as well as his untiring experiments with materials, shape and color in a quest for symbolic expression, had a great influence on the Dadaists in Zurich, who were happy to exhibit Klee's pictures and

sculptures. Similarly, Klee was also inspired by the "automatic" techniques of Surrealism, which he incorporated into his own repertoire. Dadaism's collage technique as developed by artists such as Kurt Schwitters corresponded with Klee's technique of cutting up and reassembling pictures, though Klee avoided directly introducing ordinary objects, newspaper cuttings and so on into his compositional structure, as Schwitters did extensively in his so-called Merz pictures.

The influx of Surrealism into Klee's visual world may seem difficult to reconcile with the later Bauhaus Klee, who devoted a whole decade to vigorously and systematically exploring the fundamental principles of form and color. But clearly what the Surrealists saw in Klee was not a Constructivist but first and

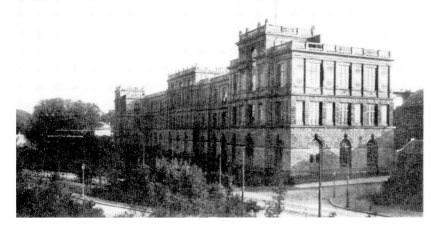

left: Klee's studio in the Dessau staff accommodation.

above: Klee's brief time at the Düsseldorf Arts Academy,
in the picture here, was his last surfacing for air before
he began the long struggle with a pernicious, ultimately
fatal disease.

foremost a poetic individualist who could conjure magical charm even out of the strictest geometry. Klee's astonishingly varied painting techniques did indeed make him a "magician of painting," who could conjure a whole inner landscape from a few lines and dabs of color.

Klee's Legacy

Klee had no successors as such, even though numerous students attended his preparatory courses at the Bauhaus. Later on, similarly, in his painting classes in Düsseldorf, Klee was seen not as a model to be imitated but as a much admired master to whom great respect was due—but who did not inspire imitation. The descriptions of his classes at the Academy in Düsseldorf (for example by Petra Petitpierre) suggest a professor of art who was conscientious but very self-centered, punctilious about doing the round in class but equally quick to disappear again. Least of all did his carefully prepared course at the Bauhaus inspire any of his pupils to take over or further devel-

op the laws of art he expounded, often with pedantic precision. Yet his pictures have manifestly had an effect and his name carries a powerful resonance that is still felt today.

The reason for that lies in his output itself. It has so many different facets, and is open to so many interpretations and responses, that the fascination with Klee is growing rather than declining, among both artists and art lovers.

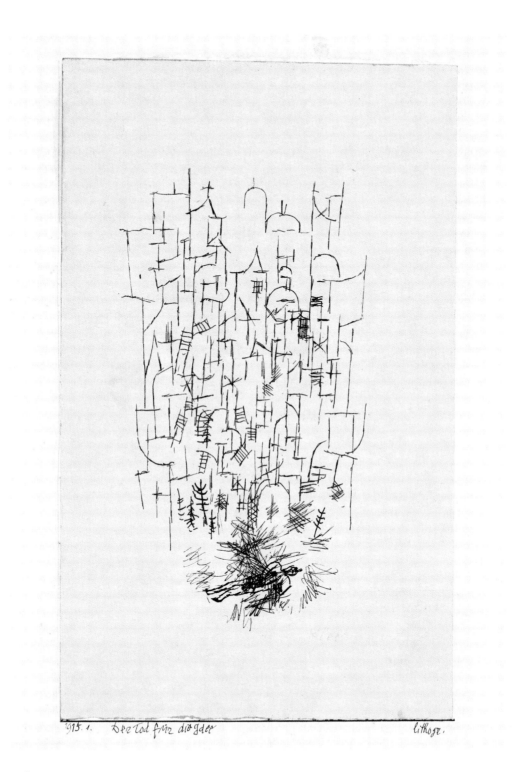

1915. 1. Der Tod für die Idee lithogr.

Obituary for a poet Klee's drawing *Death for an Idea* (1915) was reproduced in the magazine *Zeit-Echo: Ein Kriegs-Tagebuch der Künstler* alongside a late poem by Georg Trakl (1887–1914). However, Klee does not illustrate the poem, alluding instead to Trakl's suicide. The depressive poet had been unable to cope with the horrors of his work as a medical orderly during World War 1.

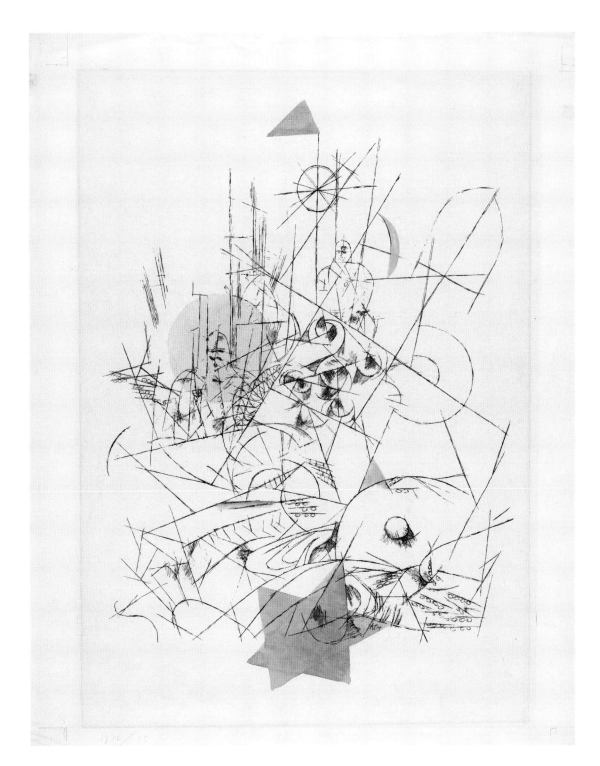

Destruction for the sake of construction? Klee's celebrated lithograph *Destruction and Hope* (1916) was also connected with World War I. Among the linear Cubist shapes in which a martial commander appears (Kaiser Wilhelm II?) is the hope of better things to come, symbolized by the star.

Art

"Art doesn't
reproduce what
we can see, it
makes it visible."

Paul Klee

Paul Klee's road to art...

... began with small, gradual steps, yet over the year developed into a comprehensive system of artistic approaches encompassing all aspects of life. Klee was not aiming at a uniform style—everything became his style as soon as he was interested in turning it into art.

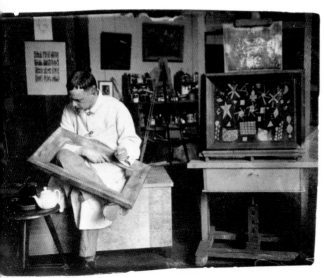

Movement

For Klee, everything comes into being through movement. He saw movement as the driving force of life and therefore the source of all artistic creation. In everything that awoke his artistic curiosity he found a life force that was a "synthesis of movement and countermovement." Everywhere he discerned a "structure of movement ... of states of growth." Discovering constant movement and change in the world in ever new contexts, he made it the motivating force in his art, as well as the cornerstone of his theory of art and the foundation of his teaching.

For Klee, the basic visual elements were...

-→ ... living forces that he had to explore.

-→ ... the building blocks that could be assembled to form meaningful wholes as works of art.

The Analogy of the Tree

In a lecture to a local arts society in Jena in 1924, Klee compared the (modern) artist to a tree. Artists have now become so familiar with the world that they are capable of organizing all the phenomena that flow through them like sap through a tree. These phenomena combine in the trunk and finally blossom into works. But these works are as diverse and varied as the branches in the crown of a tree. "It doesn't occur to anybody to ask the tree to shape the crown exactly like the roots. Everyone understands that there can be no exact mirror relationship between above and below. It is clear that the various forms of necessity bring about vital deviations ..."

But the direct reproduction of the world was what was commonly expected of artists, and they were rejected if they did not reproduce nature "like a mirror." For Klee, the true artist was very different: "Standing at his appointed place, at the trunk of the tree, he does nothing other than gather and pass on what comes to him from the depths. His position is humble. And the beauty at the crown is not his own. He is merely a channel."

With this analogy Klee described very graphically the way he saw himself as an artist. His aim was to collect the diverse stimuli of nature and in his artistic vision turn them into novel works that, though quite different from the natural objects on which he drew, always refer back to them.

Expanding Perceptions

In his *Creative Credo,* Klee examined the basic elements of graphic art and in doing so tried to describing the genesis of his works: "A wide range of lines. Spots. Dots. Surfaces smooth, surfaces dotted, hatched. Undulation. Inhibited, subdivided movement. Countermovement. ... Monophony, polyphony." The finished work is formed from these diverse movements and shapes, and in turn has to be read by the "movement" of the viewer: "Paths are set up in the work for the viewer's eye to scan, the way an animal grazes. ... The work of art are generated by movement, are themselves records of fixed movement, and are experienced through movement (eye muscles)." The components of the image become independent, living elements whose autonomy is to be explored so as to bring out the processes and functions of reality: "Art is an allegory of Creation." Thus Klee did not see himself as an "abstract artist," but as an artist who expands our perception of the world: "I managed to become an illustrator of ideas again after I'd forced myself formally. And after that I didn't see any abstract art at all. All that remained was the abstraction of transitoriness. The object was the world, even if not this visible one."

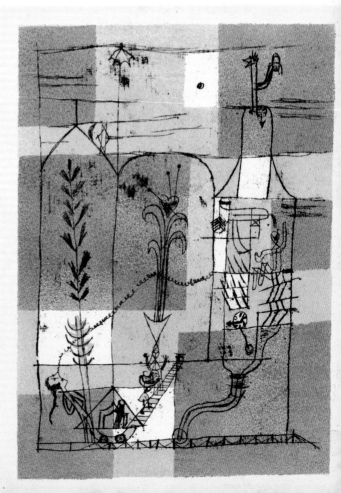

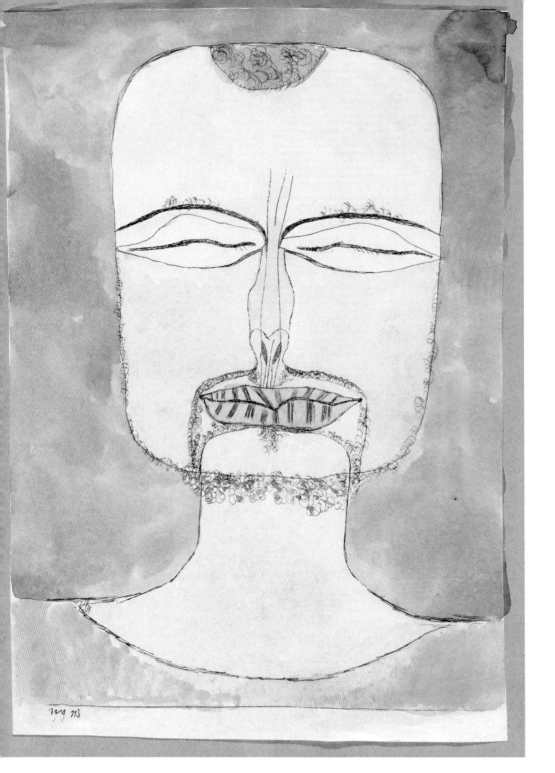

Klee's self-portrait *Absorption* impressively shows the artist turning away from the external hustle and bustle to listen to his inner voice. The artist's ego seems to be secreted in a nutshell.

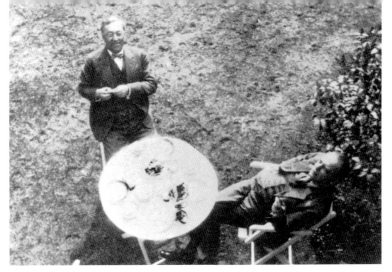

Klee and Kandinsky in the garden of the house they shared in Dessau.

The Art of Making Things Visible

Klee's oeuvre is like a spiral ever expanding upwards; or like a tree whose crown is steadily branching out in every direction (to adapt his own analogy for the creative process). As one of the first modernist artists, Klee allowed diverse styles to co-exist while he worked on various innovations in parallel.

Klee as a Graphic Artist

Klee's work went through a long period of gestation before he tried to work professionally. After his extensive training in drawing under Knirr and Stuck, Klee considered himself mainly a graphic artist. This is evident even in his first work, which he listed as Opus 1 in his private catalogue. It is a series of 11 satirical etchings, called *Inventions* and dated 1903–1905, in which he expressed his "displeasure with regard to higher things." In these etchings, Klee made use of many ideas he had picked up during his visits to the

"Until art shakes off real objects, it remains description, or literature, and demeans itself in using inadequate expressive resources and condemning itself to the slavery of imitation."

Robert Delaunay, *On Light* (which Klee translated into German)

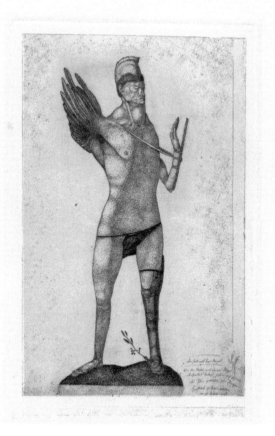

Graphisches Kabinett in Munich, where he had seen the works of Aubrey Beardsley, William Blake, and Francisco Goya. Apart from the fine technique, it is the mocking, satirical exaggeration of the subjects that stands out, for example in *Hero with the Wing* (right). Klee wrote on the bottom of the print: "The hero with the wing. Specially endowed by nature with one wing, he's come up with the idea he's destined to fly, and this proves his downfall. The wing does of course look badly clipped, while the right arm is already in splints, as if an earlier attempt at flying had already failed, the right leg is also in splints and has been transformed into a tree stump, which will probably keep the tragicomic hero permanently grounded despite all his desperate efforts. In a diary entry for January 1905, Klee formulated the first conception of this etching: "The hero with a wing, a tragicomic hero, perhaps an ancient Don Quixote. This swampy formula and poetic idea, which surfaced in November 1904, has now been drained and developed. Born, unlike divine beings, with only one angel's wing, this man makes incessant attempts to fly. In doing so, he breaks an arm and a leg, but keeps at it under the rallying cry of his idea. The contrast between his monumentally solemn attitude and his already ruinous condition needed to be recorded above all, as a symbol of the tragicomic."

Klee's oeuvre is full of winged creatures, angels, and aerial spirits. Intermediaries between the mortal and the divine, they are also—especially in the late oeuvre—consoling nods to fate.

Symbolic of mankind's never-ending striving for intellectual or spiritual perfection, the motif of flying occurs again and again. An upwards striving from the human condition is also the subject of Klee's drawing *Fading Higher, Further* (1919). It is one of a series of illustrations that Klee executed to illustrate the Expressionist poetry of Curt Corrinth's *Potsdamer Platz*. The drawing builds up into two groupings of

The subject of flight appears in many
of Klee's drawings, as it does in this
apparently abstract design, *Fading Higher,
Further* (1919), which rises like a tower
(of Babylon).

Art

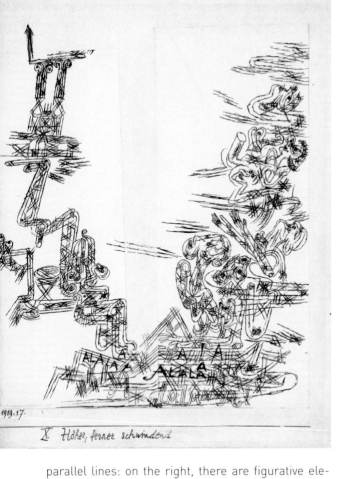

were about his own struggle with mortality, but also about the earlier subject of mankind's striving for spirituality, which was symbolized by the figure of an angel.

Klee as a Painter

It was only after the journey to Tunis in 1914 that Klee first described himself as a painter. He had indeed previously devoted himself more to drawings and etchings, observing: "I still come closest to success with drawing. When I use color the results are dubious, for these painfully gained experiences bear less fruit." The only involvement with painting was in the *Black Watercolors*, which were produced, around 1908–1909, "by adding layer upon layer of thinned black watercolor." At that time, he considered working with tonal values the "quintessence of really great painting, and not for example colorism." That would gradually change, partly because of his acquaintance with the Blauer Reiter artists, but also because of his exploration of Delaunay's abstract painting. But it was the experience of

parallel lines: on the right, there are figurative elements, heads and arms between layers of horizontal lines, while on the left architectural elements grow into a pair of Ionic columns, whose movement is carried skyward by a vertical arrow (above).

Literary sources often triggered off whole series of graphic works from Klee, one example being the masterly illustrations to Voltaire's *Candide* that he executed from 1911. The emaciated figures, drawn with thin, edgy lines, make an extraordinary accompaniment to Candide's adventures.

With the late works from 1935 in Bern, his drawing style entered a completely new phase. In 1939 alone he produced almost 30 angel scenes, in which he sought to exorcize his fears over a progressive and incurable illness that was now afflicting him. These

Illustration for chapter nine of Voltaire's *Candide*, 1911. Klee's edgy style of fine lines deftly captures the atmosphere of the scene.

color and light on the trip to Tunis that made all these encounters fruitful and triggered off a new and intense preoccupation with painting. "Color possesses me. ... color and I are one. I am a painter."

However, Klee's paintings are just as difficult to pin down stylistically as his drawings are. They range from fairytale scenes with representational associations through squares of color to Constructivist and musical compositions (polyphonies), and in the late works symbolic images as well.

For Klee, color was the "imponderable" element of a picture. "There's always something mysterious about color that's difficult to catch hold of. This mysterious quality penetrates the mind. Colors are the most irrational aspect of painting. They posses something suggestive, a suggestive power." Even so, while he was at the Bauhaus Klee developed his own theory of color that is quite distinct from those of his predecessors (Goethe, Runge, Delacroix, Chevreul, and also Kandinsky) in its special use of metaphors of music and movement.

For Klee, colors referred to cosmic aspects, and are therefore related mainly to music. Like the latter, they contained numerous opportunities for gradation, "from the smallest step to a richly flowering colored chord."

Klee used a technique of applying layer after layer to a pre-determined grid division of the sheet, so as to overlay colors step by step to produce very dark tones. This technique is reminiscent of the "time-marking procedure" of the *Black Watercolors*. The rhythmic alternation between the individual applications of color enables the genesis of the picture to be experienced through a time process indicated by the successive stages of painting. Such gradations of color can also be brought to life by graphic means, as the drawing *Battle Scene from the Comic-Fantastic Opera "The Seafarer"* shows (page 51). Drawing and painting blend in humorous figurations, the most famous of which is probably *The Twittering Machine* (page 50).

Klee tried out his color theories in these magic squares: right, *Harmony in Blue = Orange* (1923); left, *Old Sound* (1925).

Art and Music: Klee at the Bauhaus

At the Bauhaus, Klee developed a great number of techniques, motifs, and topics through which he sought to extend "boundless nature" in every direction. Right at the start of his Bauhaus period, he painted a series of watercolors and small oil paintings that the art historian Will Grohmann has described as "fugue pictures." The allusion to music is not accidental, but shows how elegantly Klee could introduce ideas of all kinds into painting. A theme, a shape, is developed through a range of variations. Against a deep black background, rectangles, triangles, circles, rhomboids and other shapes evolve into ever lighter tones, the shapes changing and being rejuvenated. These pictures are Klee's presentation both of a specific plant structure (the growth of nocturnal plants) and a general process of growth. The lightening and differentiation of the colors from dark brown or gray tones to light, warm tones relates not only to the recognition that colors arise through light, but also to the birth of all living things from the chaos of darkness.

In his Bauhaus course, Klee investigated such color series in both theory and practice to highlight "movement through color." A fine example is the watercolor *Eros* (page 41), which progresses from a blue base to an ever lighter pyramid via overlays of red and yellow tones. A color/light movement thereby unfolds against a dark ground, the directions of movement being reinforced by two arrows. Here *Eros* refers to the spiritual, creative energy that permeates all life and stimulates perpetual growth.

The botanical world, in particular the growth of plants, was among Klee's principal subject areas, and runs through his whole oeuvre. The importance of this subject lies on the one hand in the analogy to the creative process, and on the other hand in the possibility of abstracting botanical processes. Klee based many of his pictures on the way plants unfurl their leaves and blooms, using simple basic forms that "grow" over the picture surface like living organisms.

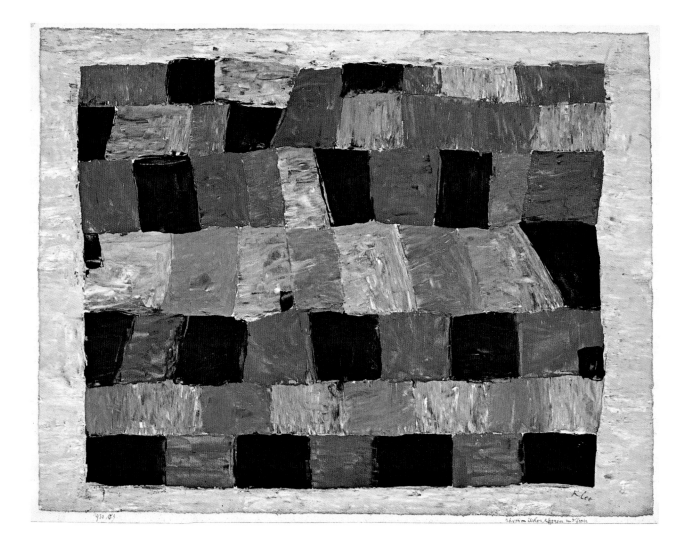

Rhythm and beat With the displacement of the structure of fields into each other, Klee achieves a strict articulation and beat-like rhythm in this picture. The alternation of coloration within the layers corresponds to a three-beat rhythm, as Klee notes in his teaching notes.

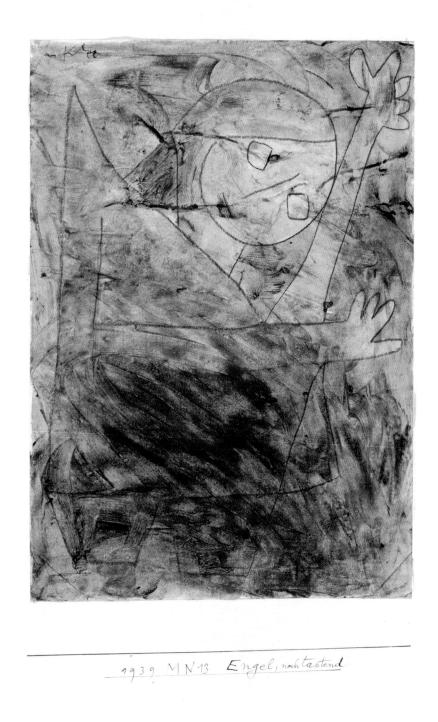

1939 VJN13 Engel, noch tastend

Angelic images The numerous pictures of angels in Klee's late works, like *Angel, Still Groping* of 1939, express a fear of death, but also invite interpretation.

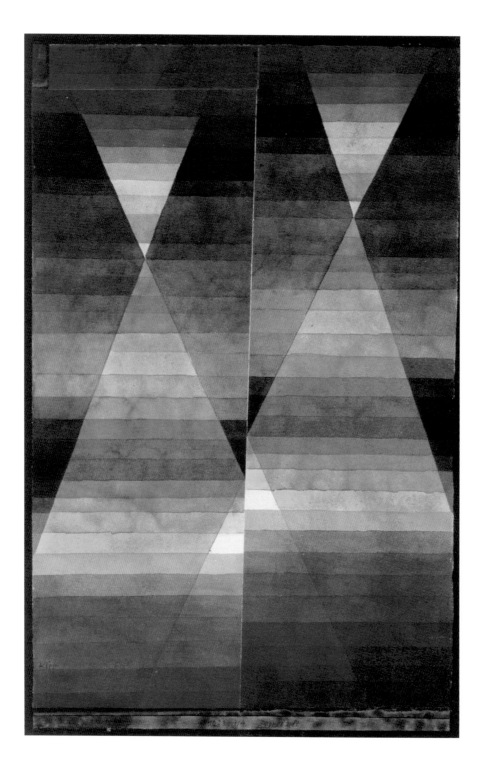

Color gradations Among the aspects of color theory Klee investigated were the gradations of shades between complementary colors (e.g. red and green), which Klee demonstrates here in a watercolor he has cut up and collaged together as *Double Tent* (1923).

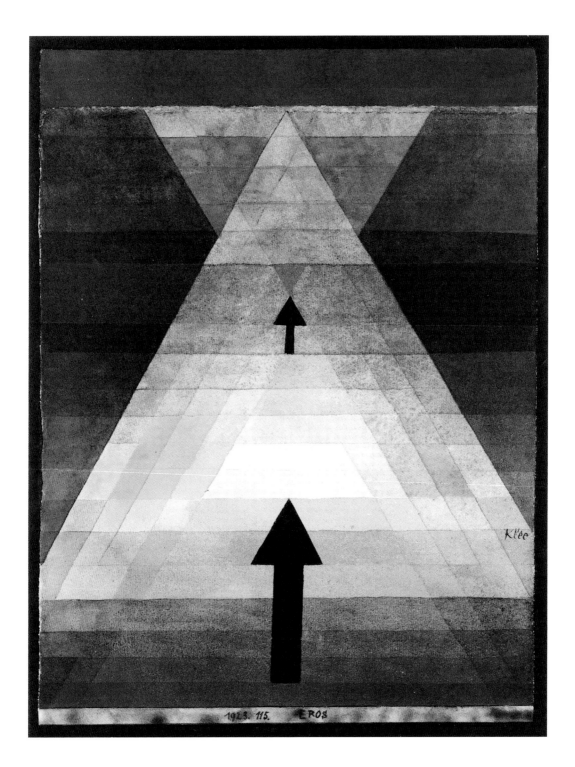

Eros in color One of Klee's finest watercolors, *Eros* (1923) shows the progression of colors between primary colors red, yellow, and blue in numerous mixes and refractions. The movement is emphasized by arrows that lead to a small red triangle.

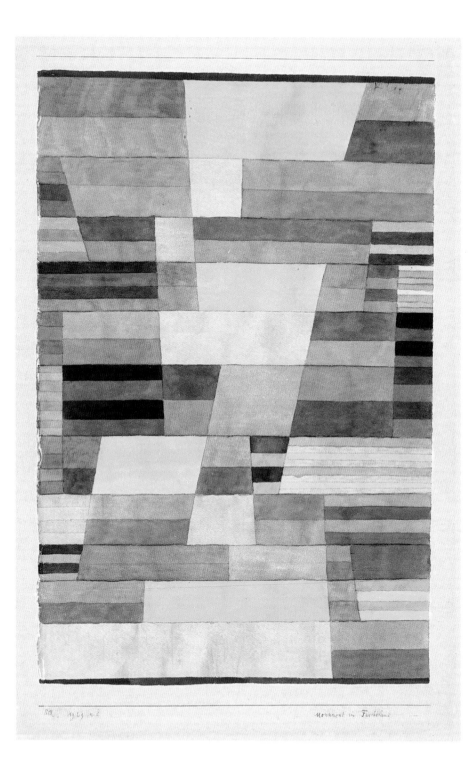

Musical articulation Klee was fond of using quasi-musical arrangements, as in this "cardinal progression". At the intersections of verticals and horizontals, the colour fields double in accordance with a notation of minims, crotchets and quavers.

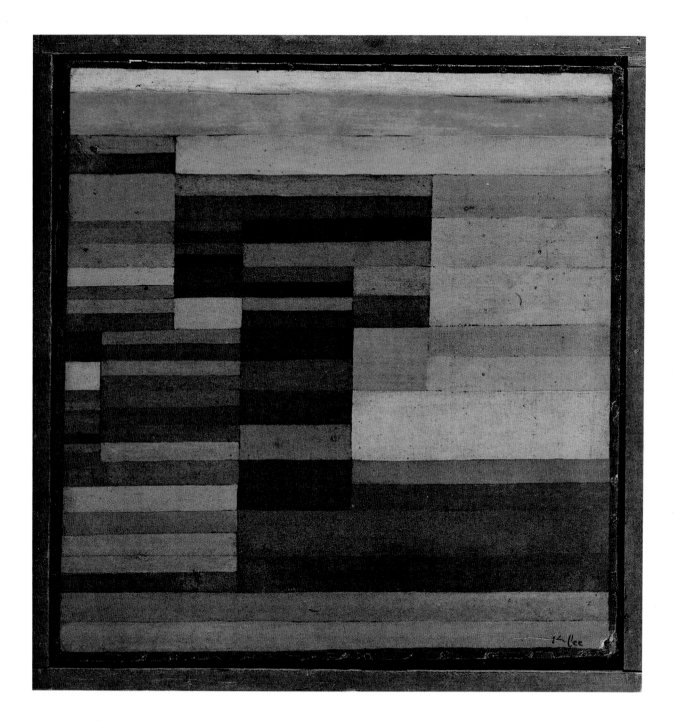

Play of colors *Fire in the Evening* (1929) also appeals to an emotional association that Klee was happy to achieve after completing the picture. However, to start with, his visual resources were focused on the structural layering of color fields. They are not schematically arranged but build up a picture as "free individuals."

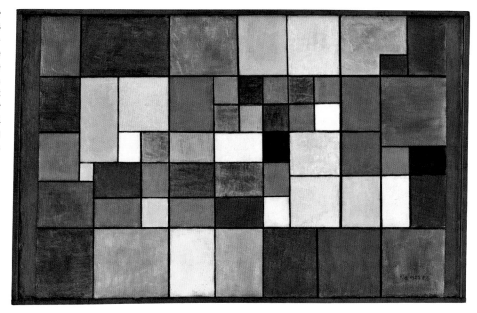

A basic structure found in Klee's pictures of the Bauhaus period is a grid of geometric shapes, which is later standardized into a chessboard pattern. Klee discovered a similar compositional pattern in Delaunay's "window pictures." The fact that the main elements in Klee's pictures are drawn from Gestalt psychology indicate that he was also interested in the psychology of perception, especially the analysis of shapes by Ernst Mach and Fritz Schumann. In such studies, our responses to simple geometrical forms were recoded: some shapes, it was discovered, evoke sensations of rising, falling or resting; in large complexes of shapes, it seems, shapes push, shove, or convey balance and stability. In his *Square Pictures*, Klee tried out all these possible ways of grouping squares into living forms. The color intensification in the squares is based on the laws of Klee's color theory, which describes the various ranges of colors both diametrically from one color to another and peripherally in transitions on the color circle.

The rhythmic interplay of color rectangles, their distribution according to principles of light/dark, light/heavy, and warm/cold, as well as the balance between various elements, followed Klee's theoretical investigations at the Bauhaus, but also developed a life of their own in the Bauhaus atmosphere, where (in the Weimar period at least) dance, music and theater were important and closely related aspects of study.

A colleague of Klee's, George Muche, who was an assistant in Johannes Itten's preliminary course at the time, records an anecdote that throws a revealing light on Klee: "Later, when Klee came to the Bauhaus in Weimar in 1921, he moved into a studio that was next to mine. One day I heard a strange, rhythmic stamping. When I met Klee in the corridor, I asked him: 'Did you hear that remarkable noise just now?' He laughed and said: 'Oh, did you notice? You were not supposed to. I was painting and painting, and suddenly—I don't know why—I had to dance. You heard it. Pity. I never dance normally.'" Klee often

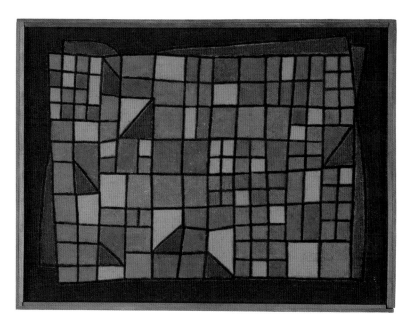

Dating from the year of his death, Klee's *Glass Façade* (1940) is a picture made up of squares of colors resembling mediaeval stained glass. A simple composition, it is modified in numerous ways by means of reflections and rotations.

carries the rhythm of his pictures over into the titles that contain the notions of rhythm, sound, and harmony, thus emphasizing the musical character of these works.

The elaboration of these themes may have something to do with Klee's friendship with Oskar Schlemmer, who ran the Bauhaus theater and whose Bauhaus dances did much to make the Bauhaus better-known to the public. The relationship probably also influenced the desire, expressed by Klee's son, Felix, for a career in the theater, as a director or artistic director. Klee designed a glove-puppet theater for Felix, with over 50 highly expressive characters that clearly demonstrate his artistic imagination in this field (page 102). There is a close relationship between art and theater in many of Klee's pictures, manifest not only in the fantastic worlds that they show, but also in his use of such features as stage perspectives, curtains and repoussoir figures that identify the pictorial space as a stage on which visual events are presented as it in a play.

The Dessau period of the Bauhaus, with its more formal teaching, produced a degree of systematization and geometricization that makes many of Klee's works cooler and more rigorous. In a new group of works, Klee combines the field structure with a stricter, chess-like articulation to generate rhythms that are like a musical beat. Beat and rhythm are important concepts in Klee's art theory, for they bring out the temporal structure of a work.

At the end of his Bauhaus period, Klee executed a series of paintings which, with their transparent, overlaid colors, he described as "polyphonic" (in music, the playing of several thematic lines simultaneously). As early as 17 July 1917 he noted in his diary: "Simple movement seems banal. The element of time has to be eliminated. Yesterday and tomorrow as simultaneous. Polyphony in music goes some way to meeting this aim. ... Polyphonic painting is superior to music in that the temporal element is more three-dimensional. The concept of simultaneity is richer and more pronounced."

In *Polyphony* (1932), various visual levels and resources intermesh in a subtle synthesis.

It was in the 1930s that Klee transferred this musical concept and the compositional approach to painting. Overlaying various structured surfaces on top of each other creates a visual polyphony, a concord of the visual resources of line, form, and especially color. A particularly subtle technical resource that Klee devised involved superimposing a grid of dense, color-contrasting dabs on a color area subdivided into rectangles. The picture thereby gains depth, transparency and, as a result of the contrast of the color field and the dots, a great richness of color and tone.

Along with the extensive theoretical formulations, there were images of machines and automatons, tracings on oiled paper, and works that exude a Constructivist spirit, as demanded at the Dessau Bauhaus. Just like Kandinsky, Klee was deeply skeptical about the Bauhaus tendency to make art scientific, and he endeavored to keep such theories at an ironic distance. The conflict between the required art teaching and his own painting became more and more difficult to resolve, however. The drawings that he did between the fall of 1931 and October 1932 in Düsseldorf look like a last echo of that period's obsession with theory and pseudo-science. They are geometric constructs of great precision and purity that anticipate Minimal Art—and are wholly atypical of Klee.

Parallel to such cool and carefully calculated constructs, increasingly common were expressions of his "craze for symbols" (as Klee described it to his wife)—floods of signs and symbols that dissolved Constructivist rigidity in expressionist sensation. Using a scrawling pen, edgily broken lines done with grease crayons, or vigorous slashing brushstrokes, Klee betrayed his hidden sorrows, fears and anxieties—the intense emotions, uneasy dreams and a sense of impending violence that were overwhelming him as the ominous political situation in Germany worsened.

Klee's Use of Materials

Klee went on developing his painting techniques ceaselessly during the Bauhaus years. He had already experimented with sundry techniques earlier

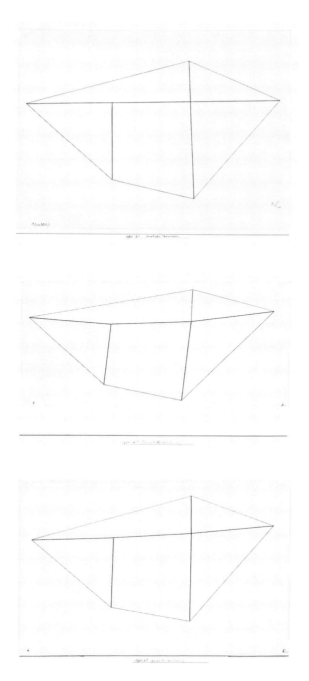

In the 1930s, he used the following materials as supports, among other things: "Jute, gauze, untreated cotton, silk, bunting, damask, handkerchief, aircraft fabric, packing paper, newspaper ..."—and for paints used all possible kinds, including oils, tempera, watercolor, gouache, "oil paints of a mural character," and everything in combination, though he was very fond of "veiling" the true nature of the coloration by means of glazes and varnishes.

In 1928, on the occasion of an exhibition of young Bauhaus painters in Halle, Ludwig Grote discussed Klee's painting techniques explicitly: "He develops hitherto unused grounds that added excitement and vibration to the support, and he handles surfaces in new ways—all in all, it was a new kind of sophisticated pictorial structure. Who before him could get such spatial depth from the weave of the canvas, or could apply a delicate stroke of the pen so lightly and loosely?"

The combination of traditional painting techniques and experimental treatments raised the question of durability, an issue Klee often chose to ignore.

and combined conventional painting methods, as emerges from a diary entry for 1910: "Mix a ground of consisting of powder-paint and limewater and apply like a chalk ground, so as to work for once on a ground that will show both light and dark to advantage from the first."

Castle in the Air dates from 1922.

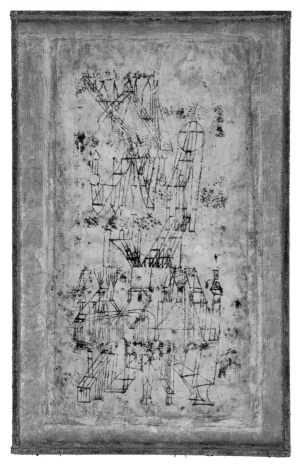

In works such as *Lying Awake* of 1932,
line itself becomes an expressive resource.

He was no doubt aware of the problem, but accepted the risk as part of the process of expanding the range of things he could say in his works. The fragility of many compositions, which is now a source of great problems for conservators, in fact parallels a specific intellectual content that Klee wanted to bring out. Studies of materials were part of the basic course at the Bauhaus. Presumably Klee used his pictures not only to illustrate his theories of form and color but also to explore issues relating to paints and materials, and also to encourage students to carry out their own experiments.

However, the fact that Klee accepted as a general principle the fragility of his pictures suggests that he actually expected the pictures to deteriorate and so deliberately explored that fact as an expressive feature. The ruinous condition of many of his pictures is therefore not a trick to make the pictures look old and venerable, but an intrinsic part of their expression and meaning. In particular, it may be a response to the precarious times he was living in.

Late Works in Switzerland

Klee's output in the last years of his life was enormous, comprising over 2,000 works, often in (for him) unusually large formats. New visual features included rune-like symbols, gestural elements that frequently dominate the background. Klee compiled a new vocabulary from them that often lends the late pictures a dramatic, rather somber tone. Yet cheerfulness and fun still constantly surfaced in them, and sustain him through his distressing illness. Traveling entertainers, angels, and remarkable hybrid creatures populate the strongly colored works, forming a whole cosmos of optimistic and tragic figures that make Klee's late work an inexhaustible treasure trove of visual invention. He had now

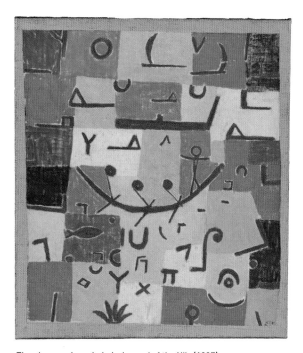

The signs and symbols in *Legend of the Nile* (1937) were initially painted on a white ground and then framed with color fields. Recalling his trip to Egypt in 1928, Klee mixes a number of recognizable objects, such as the boat in the middle and the fish beneath, in among more abstract shapes.

put the theory-laden Bauhaus period behind him. Pictures were composed with a few deftly placed strokes on colorful backgrounds in a final "ingenuous game." Harnessing the intellectual power that remained with him to the end, he created a realm of myths and fabulous creatures, not by secluding himself in an ivory tower but by being constantly in touch with international developments in art, as links with Jean Arp and Joan Miró show. A new world was created from cool abstraction that makes Klee one of the most intellectually stimulating artists of modernism.

"In the end, a formal cosmos made up of abstract formal elements is created—over and beyond their combination into tangible beings or abstract things such as numbers and letters—that manifests such close similarity to the great Creation that a breath is enough to turn the expression of religiousness or religion into fact."

Paul Klee, *Creative Credo*, 1920

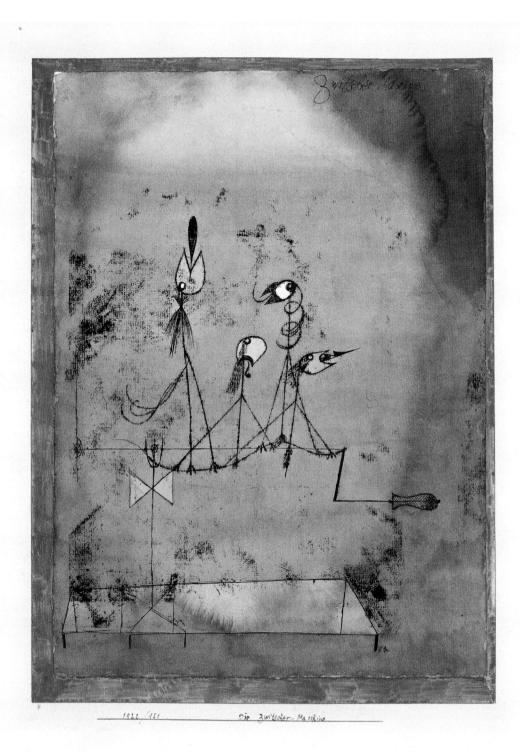

Visual joke You crank the winder of the twittering machine to hear the "voices" of the birds, which soon die away in the infinity of cosmic space, symbols of human impotence in the midst of unknown forces.

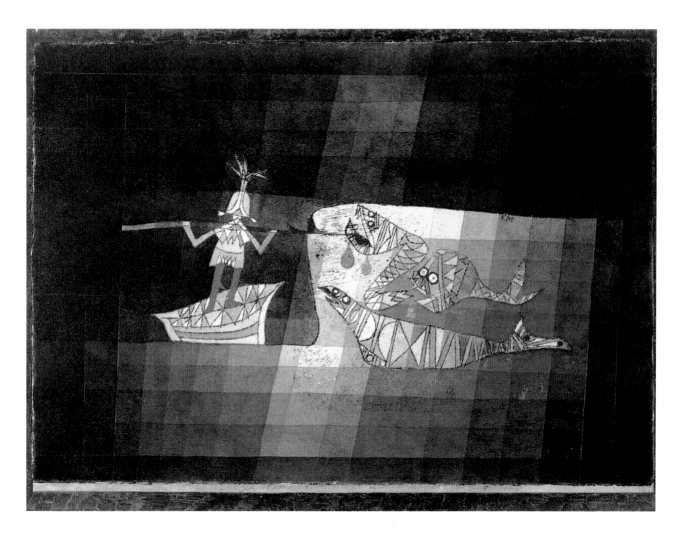

Fighting three monsters Klee loved opera, but did not make much use of it in his pictures. In this fairytale picture, a sketch for his *Battle Scene from the Comic-Fantastic Opera "The Seafarer"* (1923) he makes up a scene from an invented opera. A solitary knight fights three fishy monsters which are set against a light, gradated grid background.

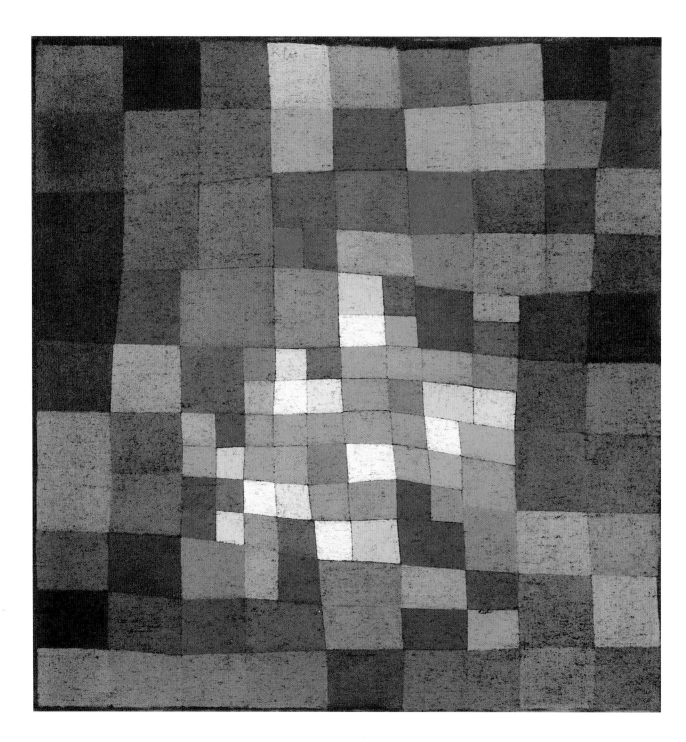

The flowering life of colors In the "square pictures" like *Things Flowering* (1934), Klee not only illustrates aspects of color theory but also gives his color fantasies free rein. This picture, for example, suggests a flowering landscape made of pure colors.

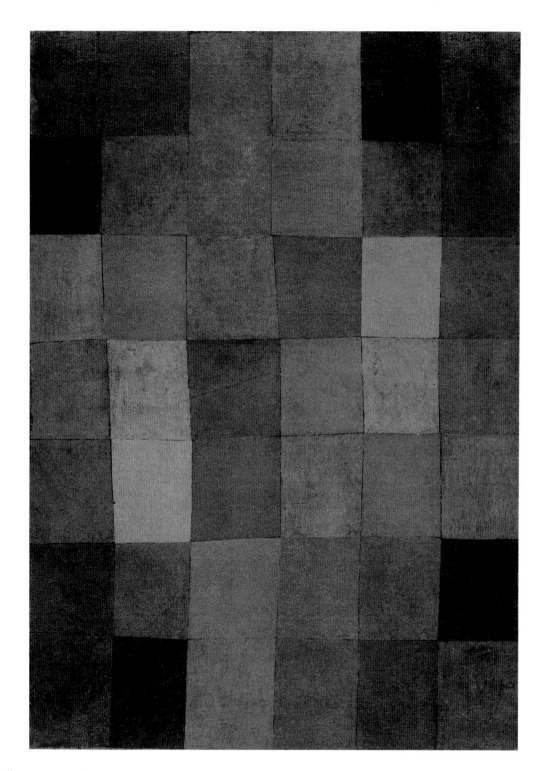

Gentle movement The fine gradations of colors in *New Harmony* (1936) also shows complementary one-off mixes between red and green tending towards gray, which was for Klee a legitimate and often used visual technique for connecting color sequences with each other.

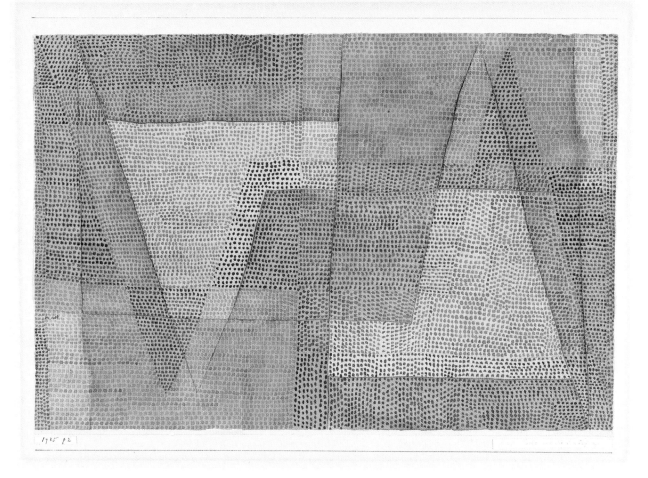

Light-filled pointillism The composition of *The Light and the Sharpness* (1935) consists of shapes interlocking in mirror symmetry. The picture plane is divided in the middle by a linear movement, and permeated by a four-part rhythm. The palette is limited to four shades of pink, yellow, light blue and orange, which are repeated four times within the 16 parts. The pointillist multi-tone screen makes this picture into an unusual "polyphonic" composition.

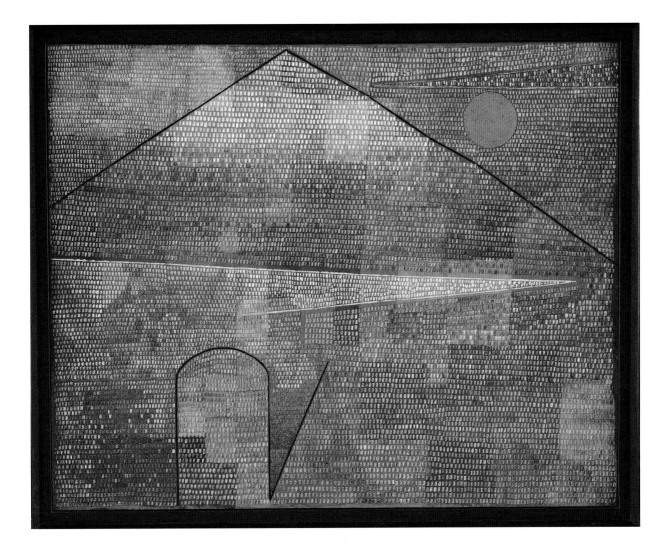

Parnassian heights The many-layered work *Ad Parnassum* (1932) sums up Klee's sundry endeavors in one magnum opus. It can be interpreted as landscape, as architecture, or as abstraction. It combines strict structural composition with lines and opulent richness of color, displaying representational symbols as well as color-theory and musical movements. With this picture, Klee reached the Parnassian heights of painting.

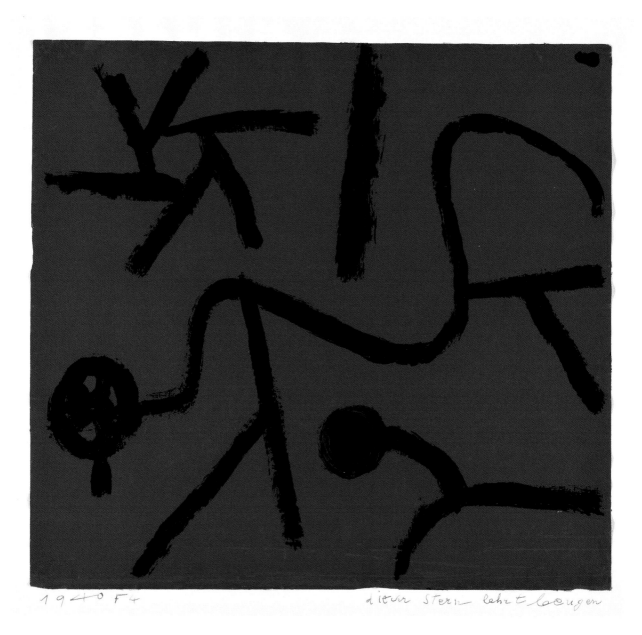

1940 F4 dieser Stern lehrt beugen

Crushed by the burden of fate Klee banishes his fear of death into a dynamic picture employing a direct symbolism. The figure looks barely human, indeed rather animal as it stoops beneath a serrated star. It is a fate he can barely cope with any more.

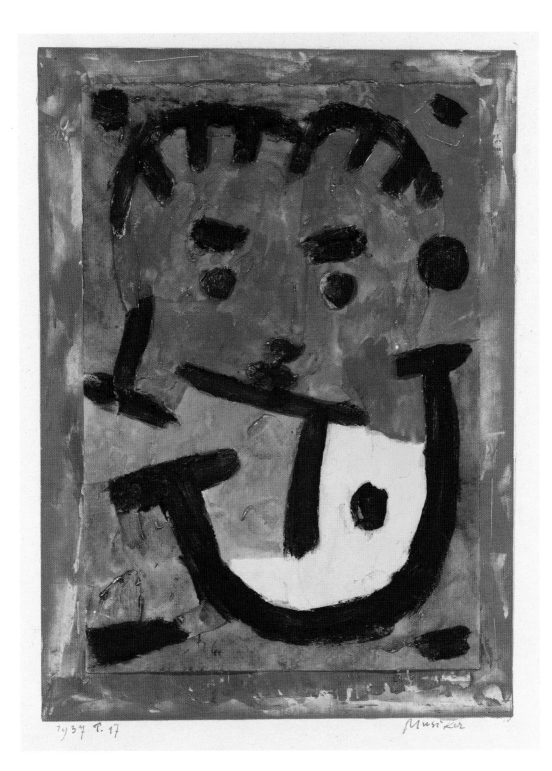

Darker times In many of these works, irrational forces, probably reflections of the political tumult and personal anxieties of the period, seem to come to the surface, as in *Musician* (1937).

"I'm not fathomable at all
in the here and now, since
I live just as well with the
dead as with the unborn,
somewhat nearer the heart
of creation than normal,
but still nowhere near
close enough."

Paul Klee

For Klee, the study of nature …

… meant more than simply looking at visible phenomena: knowledge about an object had to be expanded to include its "inner reality." By immersing himself in the laws of nature, and also by carrying out extensive research in other fields, Klee obtained the insights on which his pictures were based. Despite the many different stylistic approaches he adopted, and the wide range of subject matter he explored, Klee's style is always unmistakably his.

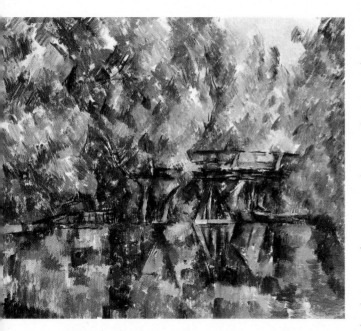

Paul Cézanne's *Bridge over the Pool*: Cézanne was for Klee a master par excellence.

Klee's Interests

Klee was quite exceptional among modern artists in the variety of sources that informed his work. His interests ranged widely, from music, mathematics, physics and chemistry to anatomy, physiology, and biology. He was a passionate opera-goer, preferring—as in music generally—17th- and 18th-century works. Wagner and modern music were not for him. He also read widely: Heine, Maupassant, Plato, Gorky, Nietzsche, Schiller, Kleist, Chekhov, Dostoyevsky, Tolstoy, Ibsen, Hauptmann, Gogol, Calderón, Byron, Keller, Molière, Shakespeare, Wilde, Voltaire, Lermontov, Baudelaire, Shaw, Morgenstern, Rabelais, Poe, Boccaccio, Balzac, Strindberg, Goethe, Defoe … and many more.

The great monuments of art and past styles of art were of course also something he studied closely, with the Renaissance appealing in particular, though he did not think its styles and values were relevant to a modern context. His judgments about the work of other artists were brief, pithy and acute: he liked the German Impressionist Max Liebermann, but "liked the French better still." Pierre Bonnard seemed to him "cultivated, no doubt, but cramped, very confined," and Édouard Vuillard "even punier." Félix Vallotton's paintings were "very unpleasant," but there was a regular guy there somewhere. Paul Cézanne, by contrast, was "the master teacher par excellence" with "much more to teach than Van Gogh." Kandinsky was the "boldest" of contemporary painters, who painted "very remarkable pictures."

Klee's *Pedagogic Sketchbook*

At the Bauhaus, Klee was obliged to turn his thoughts and ideas into teachable subject matter, and it is here that the diversity of his studies becomes apparent. He codified part of his ideas in his *Pädagogisches Skizzenbuch* (Pedagogic Sketchbook), published by Walter Gropius and László Moholy-Nagy as volume two in the series of books issued by the Bauhaus. The original pages of the book were exhibited in Weimar in the first great Bauhaus exhibition in 1923. Klee's lessons at the Bauhaus formed part of the foundation course, but were also an important element of his artistic practice. The variety of his work in the Bauhaus years is the result of a constant dialogue between his work as an artist and his clarification of his ideas while teaching. Klee's overall "pedagogic legacy," which is housed at the Klee Center in Bern, still remains to be fully researched.

Klee and Music

Klee was very attracted to music, and as he was a trained and practicing violinist his knowledge of it was extensive. In fact, he was long torn between music and art as a career, finally opting for painting because music, he believed, had already "passed its peak." By this he meant the music of Bach and Mozart, regarding the works of the latter in particular as the height of perfection. Music was a direct source of inspiration for his art. Early on in his career, he had noticed analogies between musical laws and visual structures, and during the Bauhaus period he made a particular study of the subject. In the end, he used "polyphonic painting" as a means of composition to blend various visual elements into harmonious wholes.

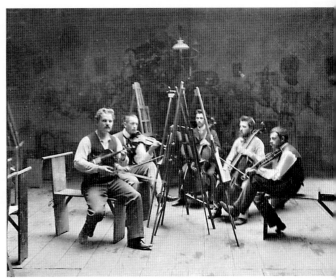

Klee in his father's garden in Bern, 1908.

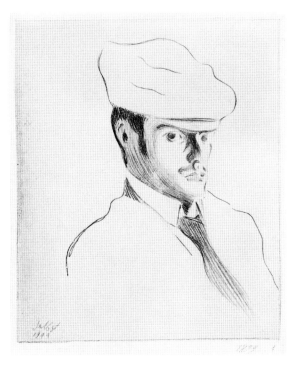

This early drawing (1899) shows the young Paul Klee in a white sports cap.

Between the Studio and the Classroom

Once he had chosen a career as an artist, Klee immersed himself in virtually all aspects of art with great determination and energy. It was a career in which he had to alternate between developing his ideas in happy seclusion, and teaching his students at the Bauhaus. It was this interaction between studio and classroom that gave his work such range and depth.

Early Years

Paul Klee grew up in a musical family. His father, who came from Franconia in Germany, was a music teacher at a college in Hofwil, not far from Bern. His mother, Basel-born Ida Frick, trained as a singer. Klee was born in Münchenbuchsee near Bern on 18 December 1879, three years after his sister Mathilde. In 1880, the family moved to Bern. Though Klee was born in Switzerland, he was legally German, for his father was a German national.

"There's nothing Faust-like about me. A thousand questions remain unspoken, as if answered. There are neither doctrines nor heresies there, as the possibilities are boundless. Only faith in them lives creatively in me."

Paul Klee

This early self-portrait shows the artist in a pensive or brooding attitude, which is part of his self-stylisation.

Young Paul started the violin aged seven, and by the age of eleven was good enough to play in the Bern Orchestra as an occasional player. After matriculating, he nonetheless decided against becoming a musician, opting instead to train as an artist in Munich. In the brief curriculum vitae he wrote a few months before his death, he wrote about this momentous decision: "Superficially, the choice of career went very smoothly. Although with my matriculation result I could have done anything, I wanted to have a go at training as a painter and chose art as a career. At the time—and to some extent even today—putting that choice into effect meant going abroad. All you had to do was choose between Paris and Germany. Germany suited me better temperamentally."

After a preparatory period of study at Heinrich Knirr's art school in Munich, in October 1900 Klee was admitted to Franz von Stuck's painting class at the celebrated Munich Academy. A year later he gave up, however, trying without success to switch to the sculpture department. He thus left the Academy without any academic qualifications, and with his fellow student Hermann Haller embarked on a journey to Italy. Prior to that, he had secretly become engaged to pianist Lily Stumpf.

The trip to Italy was of great importance for his artistic development, not so much because of the external impressions the historic Renaissance and Baroque buildings and art treasures made on him, but because of his own inner development. In May 1902 he returned to Bern and continued his scientific studies. The next trip, in 1905, took him to Paris, where he familiarized himself with the work of the Impressionists, though without seeing the modernists Paul Cézanne or Henri Matisse.

His marriage to Lily Stumpf in Bern in 1906 strengthen his resolve to return to Munich in order to be closer to the heart of intellectual and artistic developments. For the time being, it was Lily who supported the family by giving piano lessons—following the birth of their son Felix in 1907, Klee remained at home in their flat in Schwabing as a househusband

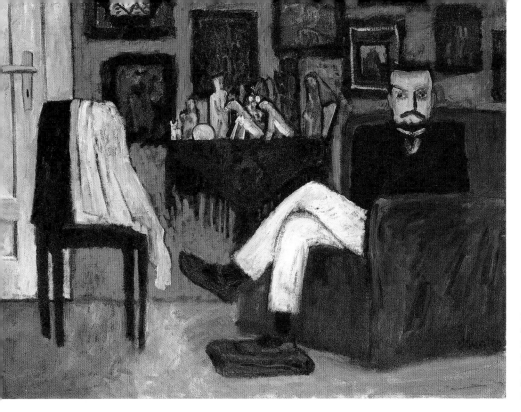

In 1913, Gabriele Münter caught Klee in a characteristic pose: as a taciturn but very attentive listener during one of the Blaue Reiter art discussions at the "Russian House" in Murnau.

and father. It was Alfred Kubin's purchase of a drawing in early 1911 that at last brought Klee into contact with the Munich art scene again. It was a time of great turbulence in avant-garde art as the Neue Künstlervereinigung München (NKVM) was riven by strife, which finally led to the departure of Kandinsky, Münter, and Marc from the group. August Macke, whom Klee already knew from a visit to his childhood friend Louis Moillet by Lake Thun, was the one who introduced Klee to Kandinsky. Despite Kandinsky's being 13 years older and a hothead in matters of art politics, Klee was drawn to him, feeling the Russian's pictures were "very remarkable." Klee thus soon became one of the Blauer Reiter group of friends.

The Blauer Reiter

Klee's isolation had finally ended. He was now involved in all the turmoil as the Munich avant-garde endeavored to promote modernist art. Of key importance were the two Blauer Reiter exhibitions, and Klee was represented in the second of these in 1912,

showing 17 drawings. He was also represented in the published almanac that followed, with a pen-and-wash drawing, *The Stonemasons* (1910). Klee listened attentively to the discussions between the artists, whom he gradually came to know, such as Gabriele Münter, Franz Marc, Alexsei von Jawlensky, Marianne von Werefkin, and Heinrich Campendonk. A few cartoons on postcards he sent to these artists indicate his emotional and intellectual support for their "battle for modernism."

A particularly tender and perceptive record of Klee's presence in this illustrious circle is Münter's painting *Man in an Armchair* (above) and her own comment on it: "When the dog days arrived in 1913 and Klee sat in my studio for the first time, and was duly admired in his white summer trousers, I saw him vividly against the wall with the old *verre églomisé* paintings, beside the little table packed with carved wooden folk art figures. I let the men do the talking, and meantime recorded the scene with a few strokes of the pencil. The result of this was the large painting of the same

Kandinsky was the fascinating doyen of the Blaue Reiter group. His pictures, like this *Study for Composition II*, are largely abstract expressions of his theories on art.

name to which Kandinsky gave a prime position in the first German Autumn Salon, organized with great to-do by Herwarth Walden in Berlin in 1913. It is not intended as a portrait, as the title indicates, but is a picture recording a visual experience, with its darknesses and mysterious variedness emphasizing the almost ironic gleam of the white trousers. And yet, unexpectedly, perhaps the real character of Klee as a man and an artist is expressed in this paradoxical representation. The physical existence in the world is surprising, and the mind leads a life of its own, absorbed in the sound of things and in itself."

In fact, Klee was not quite as uninvolved in events as he seemed, as is evident from his review of the first Blauer Reiter exhibition in the *Kunstbriefen* arts column he wrote for the Swiss monthly *Die Alpen*, keeping readers in touch with cultural events in Munich. He stressed the "childlikeness" and strange-looking "primitiveness" of the Blauer Reiter pictures, seeing it as a sign of a new art that wanted to "get to the heart of things." In the March column about the

second exhibition, in which he himself exhibited, he announced the publication of the *Almanac* without discussing any pictures, singling out instead the Cubists Picasso, Derain, Braque, and Delaunay, who were also on show at Goltz's gallery.

He was clearly intrigued by these artists, since in April 1912 he and Lily took a second trip to Paris. He visited Delaunay, Le Fauconnier, and the Swiss artist Carl Hofer in their studios, went to the Salon des Indépendants and called in on the art dealers Daniel-Henry Kahnweiler and Wilhelm Uhde. In Delaunay's studio, he saw the new "window pictures," which left a lasting impression, and talked with the French artist about his theories and methods. In 1913, the periodical *Der Sturm* published Klee's sympathetic translation of Delaunay's treatise on light, in which he formulated thoughts on abstraction that would also become important in Klee's own development as an artist.

The Moderner Bund's exhibition in Zurich in 1912 showed works by both the Blaue Reiter artists and

August Macke recorded his friend and fellow artist in 1914 with a few, closely observed strokes, in a mood between dreamy pensiveness and alert openness.

breathing freely"), pictures of that kind ultimately remained alien to him. The most important thing for Klee at this time was his contact with other artists such as Macke and Marc, gallery owners such as Hans Goltz in Munich and Herwarth Walden in Berlin, and noted collectors of modern art.

Tunis and the Experience of Color

Up to this point, Klee had been a graphic artist rather than a painter. His attempts at painting were very modest, being limited to a number of landscapes and to his so-called *Black Watercolors*, which consist of only light and dark tones. Often in the life of an artist, it is an experience, an encounter or a journey that cuts the knot, quickening the pace of development exponentially. For Klee it was the trip to Tunis with August Macke and Louis Moillet in April 1914. In a later dairy entry, he described the experience of color and light in the Tunisian landscape as a revelation: "It [color] suffuses me so softly and gently, I feel it and become so sure of it without effort. Color possesses

the Cubists, in response to which Klee wrote a very partisan review in the August issue of *Die Alpen*. Following comments on the "dismembering" of objects in the Cubists, he passes on to a paean of praise for Delaunay. The contradiction of "indifference towards representation and at the same time advertising it by means of gross maltreatment" was remedied in astonishingly simple fashion by "the very artist who labored longest on it, Delaunay, one of the sagest of our time—he created a genre of autonomous picture that leads a wholly abstract formal existence without a subject from nature."

Klee himself, however, was still unwilling to sign up for such theoretical visions. Though he was astonished by Kandinsky's daring ("nothing despotic,

The trip to Tunis in April 1914 was a revelation of color and light for all three artists, August Macke and Louis Moillet as well as Klee.

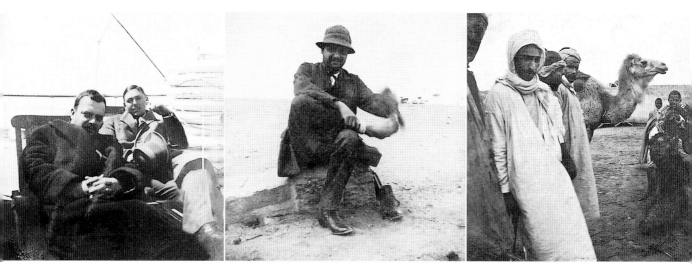

me. I don't need to grab at it. It has got to me for good, I know. That is the meaning of the happy hour: color and I are one. I am a painter."

In the mere 13 days that Klee spent on this trip, the three artists went on expeditions through the Arab districts of Tunis, explored the surrounding area (in the automobile of Tunis-based physicians Dr Jäggi and his wife, who came from Bern), went to the sea, visited Sidi Bou Said, Carthage, and the town of Hammamet, and on the 15 April reached their main destination, Kairouan. Klee was so overwhelmed by the experience that he could hardly paint his intended watercolors, and decided to return home. On 19 April he had already embarked for Europe; Moillet and Macke stayed on in Africa for a few days. Artistically, the importance of this journey undoubtedly resided in the breakthrough to color and painting, which for Klee was associated with a series of watercolors and pictures he painted once he was back in Munich. In these pictures, he linked the experience of color and light with Delaunay's "window picture" in order to

create compositions that were a synthesis of "urban development architecture" and "visual architecture." Whereas the watercolors painted on the spot in Tunis continued to preserve a recognizable connection with the landscape, back in Munich Klee experimented with more abstract paintings.

Klee and the World War I

A few months after the journey to Tunis, World War I broke out. The friends in the Blauer Reiter group were scattered far and wide: Kandinsky, Jawlensky, Werefkin and all the other Russians had to leave Germany; August Macke and Franz Marc enlisted and were in due course killed at the Front; Campendonk was called up in 1915. Klee was left alone in Munich, for the time being spared from military service. In his letters and diary entries, he shows none of the general nationalistic enthusiasm for war: "I've had this war in me for ages. That's why it doesn't concern me inwardly." In a response to Marc's belief in the "purification of Europe" by war, Klee remained

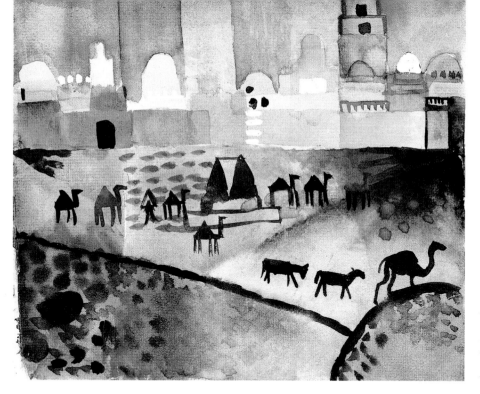

August Macke initially set down his impressions on the spot in a naïve, narrative style, as here in *Kairouan I*, before producing a more considered version in oils after the trip.

distant, finding the meaning of life only in art. It was an attitude expressed even more forcefully in the obituary he wrote when Marc was killed. This much-quoted text sets out an artistic ethos that Klee had long sought. Drawing a line between his own and Marc's attitude to art, he now says: "I seek an out-of-the-way point where creation springs, where I divine a kind of formula for people, animals, plants, earth, fire, water, air and all circulating forces at the same time."

But despite thinking himself a non-participant, on 11 March 1916 Klee was called up, the very day he heard of the death of Marc. His father intervened to prevent Klee being sent to the front, so he was detailed to the "air replacements" department in Schleissheim, painting planes "in accordance with his profession"; from January 1917 to the end of 1918 he was paymaster in the flying school at Gersthofen, a relatively peaceful existence. But it was to the war, from which he had already mentally withdrawn, that he owed his new success as an artist, celebrating his first solo show at the Sturm Gallery in Berlin in March 1916. In the peace and quiet of his free time, Klee had found a style of his own that, building on the experiences of Kairouan, now included poetic, fairytale content that suited the taste of the bourgeois public. The frequent allusions to planes and flying in his picture is no doubt largely due to his war experiences in Schleissheim and Gersthofen.

Klee returned from the war a successful, established artist about whom more than one monographs was being written (Leopold Zahn, *Paul Klee: Leben, Werk, Geist*, 1920; Wilhelm Hausenstein, *Kairouan, oder eine Geschichte vom Maler Klee und von der Kunst dieses Zeitalters*, 1921), and found himself in the center of the newly flourishing cultural reform movement of the Weimar Republic. As a sign of his artistic maturity, Klee concluded his diary, but started work on programmatic texts and essays on art, notably his *Schöpferische Konfession* (Creative Credo), written in Gersthofen in 1918 and published in 1920.

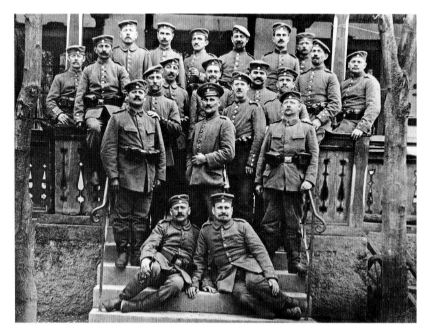

Paul Klee's Landsturm Company unit in Landshut (Paul Klee standing in the middle of the second row), summer 1916.

The Bauhaus Period

After the collapse of Wilhelminian Germany, there was a hunger for political and cultural change. Klee himself willingly accepted this desire for change, supporting a new artistic approach whose products were to be accessible to ordinary people again. "This new art could then permeate craftwork and bring forth great things. Because there would not be academies any more but only art schools for craftsmen." Architect Walter Gropius had managed to establish a "reform college" of this kind in Weimar in 1919 by merging a school of art with a college of arts and crafts. Under the broad concept of architecture, the gap between "higher" pure art and "lower" applied art—ultimately the division, for the Bauhaus, between art and life—would be overcome. Gropius wanted to establish a "republic of the minds" in this college, and therefore appointed the most important modern artists of his day as teachers. After Lyonel Feininger, who came to the Bauhaus with Johannes Itten and Gerhard Marcks in the year it was established and headed the print shop, Gropius appointed Klee and Oskar Schlemmer in October 1920. Klee subsequently headed various workshops, such as those devoted to book binding and later to glass-painting, introduced a design course in the weaving department, taught life drawing (like Schlemmer), and worked intensively on a course on the "elementary design of planes."

Kandinsky arrived at the Bauhaus in June 1922, replacing Schlemmer as head of the mural workshop, and from 1925 giving classes in analytical drawing and abstract formal elements. Parallel with Klee, Kandinsky also taught the elements of form and color. In 1926, Kandinsky's *Point and Line*

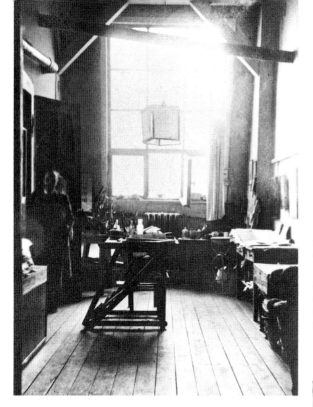

left: Paul Klee in his studio in
Weimar, 1925.

below: The Bauhaus *meister* on the
roof of the new Bauhaus building in
Dessau, 1926 (Paul Klee fourth
from the right).

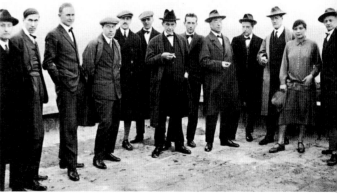

to Plane appeared, in which all the essential elements on the relationship between abstract shapes were expounded.

Klee and Kandinsky

During the years when they were both at the Bauhaus, a professional friendship developed between Klee and Kandinsky, who already knew each other from their Blauer Reiter days. This was reflected externally in their occupation of a "double house" for masters in Dessau from 1926. It was not a close, intimate friendship; it took the form of a courteous, factual exchange that involved not criticizing each other's work. Klee wrote a short appreciation for the exhibition catalogue at the Galerie Arnold in Dresden on Kandinsky's 60th, which made his admiration and understanding of his older colleague clear: "Many come to fulfillment quickly (like Franz Marc), others have the time to make decisive ... steps into new terrain in their fifties and then develop what they have acquired to the full."

The photograph of the two artists in a variation of the pose on the famous Goethe-Schiller memorial in Weimar, taken during a shared holiday in the south of France, documents their comfortable relationship, which was based on deep respect for each other's work and personality. After 1928, Klee and Kandinsky were the only Bauhaus artists who were allowed to teach their kind of abstract painting to a handful of pupils in free painting classes.

Another connection between Klee and Kandinsky at the Bauhaus was the setting up of the Blaue Vier (Blue Four) group in 1924, the other two being Lyonel

Color possesses me. ... I am a painter In April 1914, Paul Klee, August Macke, and Louis Moillet went to Tunis together. There, the three painters discovered an atmospheric landscape, especially in its colors and light. Klee was soon so full of impressions that he had to set off for home earlier than intended so as to turn his experiences into art.

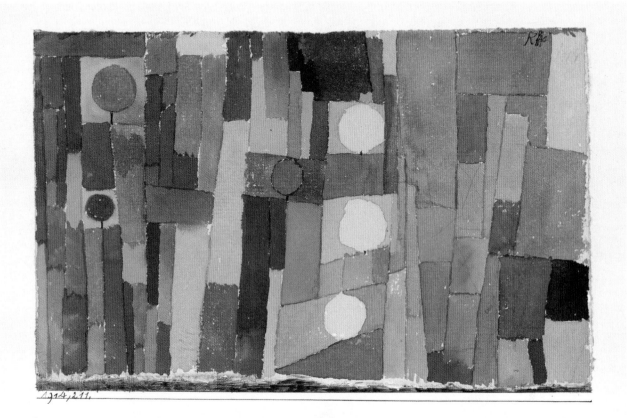

The harvest of a summer The abstract picture *In the Kairouan Style, Tempered* (1914) was painted by Klee immediately after the trip to Tunis. The composition consists of small and larger rectangles, some of them enclosing circles. Whereas in the left half of the picture muted colours predominate, towards the centre the colours gain brilliance and intensity, only to die away in subdued secondary colours again on the right.

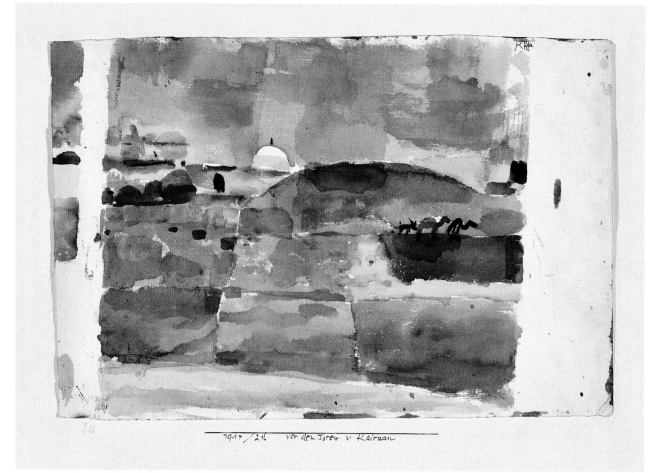

Color and light Klee produced the watercolor *At the Gates of Kairouan* (1914) on the same day that he noted in his diary "I am a painter!" A web of color glazes are imposed on top of a delicate preliminary drawing. A few representational allusions complete the impression of a picturesque desert landscape.

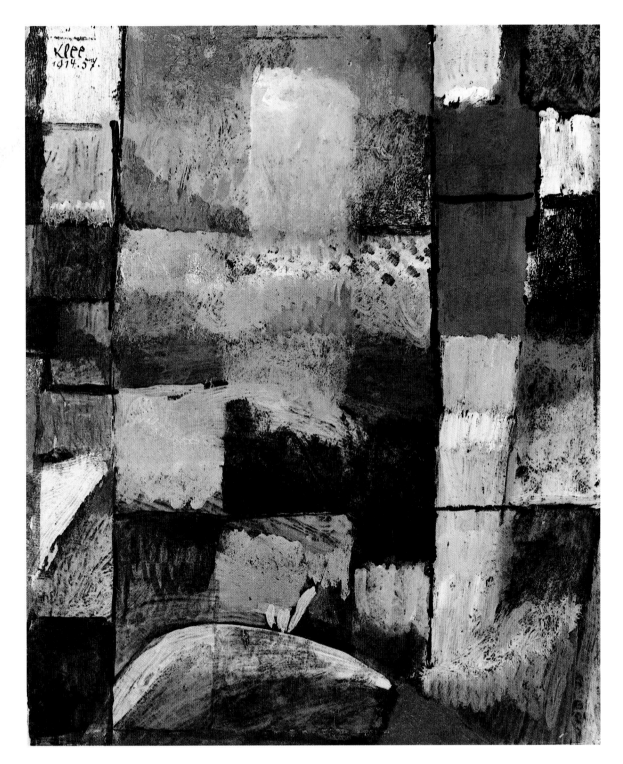

Abstraction and empathy Klee absorbed his experiences from the trip to Tunis in unconventional abstract pictures such as *On a Motif from Hammamet* (1914), which is constructed from structural color fields in the vein of Robert Delaunay. Symbols introduce landscape associations.

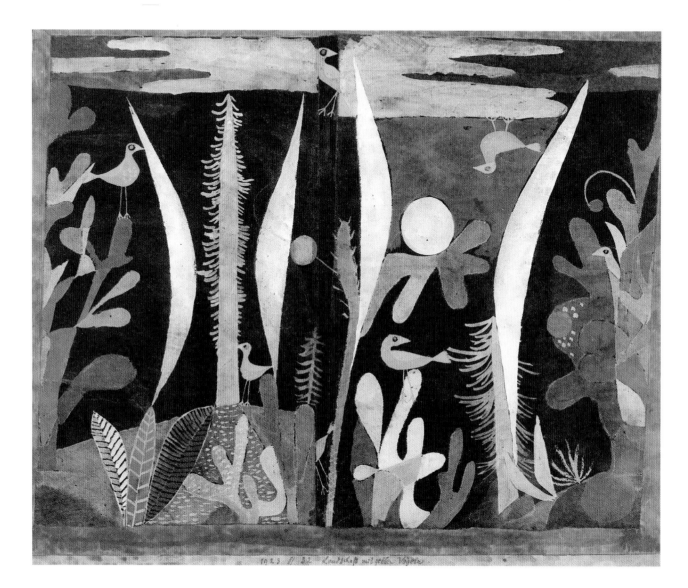

Fairytale scenery In the early 1920s, Klee had success with fairytale pictures such as *Landscape with Yellow Birds* (1923–1932), which seem to give modernism a colorful and entertaining character. But Klee was aiming at much more than just updating fairytales. He was always putting across a holistic view of the world.

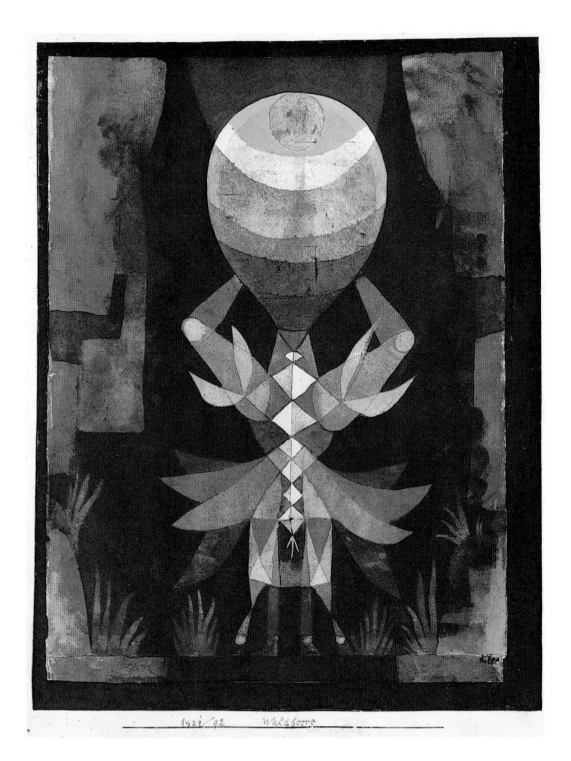

1921/92 Waldbeere

Putting color theory across in pictures Klee liked to explain his visual theories in his own pictures. The picture *Forest Berry* (1921) illustrated the movement between two complementary colors (in this case, yellow and violet) for his Bauhaus students. Nonetheless, the picture is in itself a feast for the eye, with luminous colors and an imaginary figure.

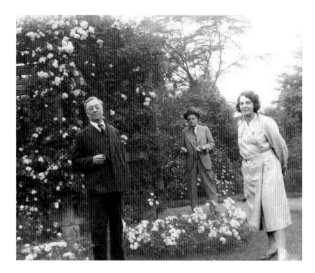

Feininger and non-Bauhaus member Alexsei von Jawlensky. The Blue Four was founded at the initiative of Emmy (Galka) Scheier, who organized exhibitions and lectures in the USA. The name Blaue Vier was a subtle reminder of the Blauer Reiter (Blue Rider) period, and helped to make the works of the four artists known to a broad American public. As a result, Klee's pictures were bought by American collectors early on.

Klee's Teaching

Klee's most important contribution to the Bauhaus was his foundation course, which offered students a follow-up to basic design after they completed Itten's preliminary course. The carefully prepared lectures on design were published as *Beiträge zur Bildnerischen Formlehre* (Contributions to the Theory of Form). Alongside these, there were over 3,000 drawings (which can now be seen at the Paul Klee Foundation in Bern) that Klee wanted to work up into a book called *Bildnerische Mechanik* (Mechanics of Art).

Unlike the other design courses at the Bauhaus, Klee's was applicable only to painting. Students were offered a logical exposition of artistic resources, which ended with a separately elaborated theory of color. Movement was the core notion at the center of Klee's artistic thought, and was a *sine qua non* of a work of art: "Works of art are generated by movement, are themselves records of movement, and are viewed through movement (eye muscles)."

All formal elements served this expressive objective both of being movement and also of expressing movement symbolically. Thus in the pictures, various forms of motion are often indicated with the symbols of gyration, pendulums, spirals, and

Klee and Kandinsky maintained a cordial friendship. In 1929, they went so far as to have a shared summer holiday together in Hendaye, France.

arrows. Even color, that most "incalculable element," is seen as a series of movements that unite the different laws of color in a never-ending process ("canon of color tonality").

In contrast to Kandinsky's theory of form, which was an analysis of basic formal laws, Klee's explanations are couched in a heavily metaphorical language and deal with how artistic motifs and subject matter are generated. Klee also refers to his own pictures as examples, though avoiding any reference to sense and meaning. At the heart of his teaching was always the genesis of the work, showing how visual elements are put together to make a formally closed composition. Time and again, Klee looks for possible associations with nature and its laws, an understanding of which was, in his view, essential as a foundation of artistic practice.

In 1924, Klee gave a lecture at the Jena Kunstverein during an exhibition of his works, expounding his notion of art and referring to the Bauhaus: "Sometimes I dream of a work of very great breadth covering the entire span of elements, representation, content and style. Undoubtedly it will remain just a dream, but it is good to imagine this still very vague possibility once in a while. It can't be done precipitately. It has to grow and to mature, and when the time is ripe for it some day, for that work, so much the better. We have to go on looking for it. We have found parts of it, but not the whole thing yet. We don't have the ultimate strength, yet. We don't have a people behind us. But we're looking a people, and that's what we've started work on, over at the State Bauhaus. We started there with a community, to which we all give what we have. We can do no more."

After the Bauhaus moved to Dessau in 1925, this systematic elaboration of the theoretical side of teaching tailed off and then dried up completely. Especially after the appointment of the Swiss architect Hannes Meyer as director of the Bauhaus in 1928, Klee began to withdraw from his teaching duties and devote more time to his own painting. The increasingly political polarization of the Bauhaus, which

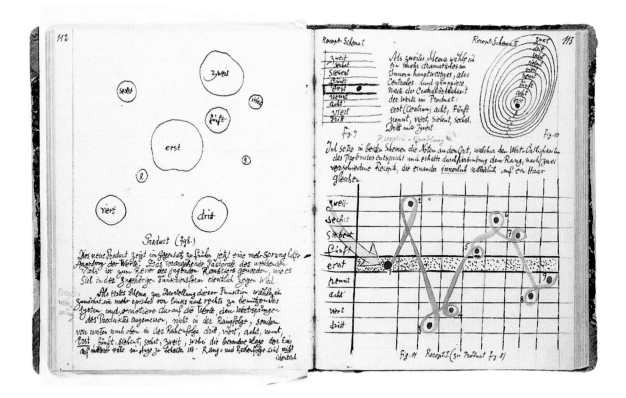

A double page from Klee's teaching notes, later published as *Beiträge zur Bildnerischen Formlehre* (Contributions to the Theory of Form).

even Ludwig Mies van der Rohe, the Bauhaus director from 1930, could not remedy, forced Klee to give up his post at the school. In 1931, he accepted an appointment at the Art Academy in Düsseldorf, where his fellow artist from Blauer Reiter days Heinrich Campendonk had been teaching since 1926.

Klee at the Academy in Düsseldorf

Klee was able to teach for only five semesters in Düsseldorf before the Nazis dismissed him without notice at the end of the summer term 1933. When he arrived in Düsseldorf in 1931, he was 51 years old and had an international reputation as an artist. Even so, the rather conservative-minded art establishment in Düsseldorf received him with reserve at best, at worst with overt hostility. Even some of his friends saw the appointment as rash. To dispel any misgiv-

ings, the Rhineland-Westphalia Kunstverein (art society) put on a major exhibition of 252 works in June and July 1932 jointly with the Galerie Flechtheim. Of these works, 148 were owned by Rhineland museums and private collectors. It would appear that here, too, Klee could count of the support of a large number of friends and admirers. Thanks to the tolerance of the director of the Academy, Dr Walter Kaesbach, Klee was accorded all possible artistic freedom. He was not tied down by fixed lessons, and he had the use of a large studio, where he spent his time behind closed doors constantly at work and occasionally making music. His teaching activity was confined to commenting on the works of his pupils, which he did at regular intervals of 8 to 14 days.

His pupil Petra Petitpierre has left us with an account of these strange encounters: "There were about ten

Paul Klee in Dessau, 1926.

of us studying at the State Art Academy in Düsseldorf, alternately producing our own drawings and paintings. ... We had prepared everything by putting the works up on walls, easels and tables ready for strict criticism and analysis. Then along came Paul Klee, and after saying hello looked at everything closely, asking for the sequence to be rearranged if necessary, delivering his opinion about the movement in a picture, often by imitating it, meanwhile walking up and down all the time ... When the lessons were over, the *meister* offered us cigarettes, lighting up himself—as a 'reward,' he said—and then we'd chat a little. ... If Paul Klee had no time, he'd be off straightaway, leaving us our cigarettes, fully aware that we would stay together a while."

Klee felt extraordinarily at ease in Düsseldorf, although because he still had no accommodation for his family he had to shuttle back and forth between Dessau and Düsseldorf every 14 days. He went to concerts and performances at the theater run by Luise Dumont. With Axel Vömel, manager of the Galerie Flechtheim, he went on extended trips to the Lower Rhine and Siebengebirge area. This tranquil existence came to an end overnight when the Nazis assumed power. Newspapers attacked Klee's work as "degenerate" and accused the artist (incorrectly) of being a Jew. His position at the Academy became

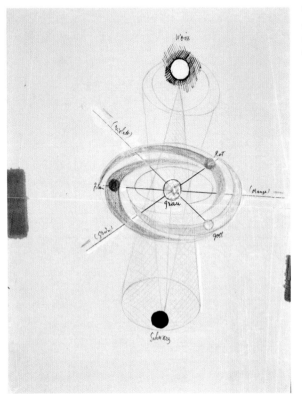

The "canon of color totality" demonstrates the movement of colors on the color circle in diametrical movements across the common gray point. All relationships of the colors follow in sequence, interweaving like in a canon in music.

increasingly untenable. Kaesbach was the first to be dismissed, in March 1933. Further dismissals came a few weeks later, Klee being given notice at the end of the summer term in 1933. Initially, he still refused to leave Düsseldorf, particularly as he had just installed his family in a spacious apartment. However, as things got steadily worse, and his life even appeared to be in danger, on 23 December 1933 he decided to move to Bern.

Last Years in Exile

Once again, Klee had to start from scratch. All con-

tact with Germany was broken off. Sole representation of Klee by Flechtheim, which the gallery had taken over from Goltz of Munich in 1925, was abandoned because the gallery owner himself was Jewish and in great danger. With his consent, Klee came to an arrangement with the famous dealer Daniel-Henry Kahnweiler in Paris.

The Klees lived quietly in a three-room apartment in Bern, Klee resuming contact with old acquaintances from his youth. Though he went on painting, the pace of production dropped noticeably. In 1934, he executed 219 works, a year later only 148.

Although he had grown up in Switzerland, his fame as an artist had not been fully recognized in his homeland. His naturalization application was initially turned down, and he was told to wait five years. Although a retrospective of his works, opening on 23 February 1935 at the Kunsthalle in Bern and shown subsequently in Basel and Lucerne, was some consolation, there was nothing to make up for the loss of his old reputation, of his contacts with friends and

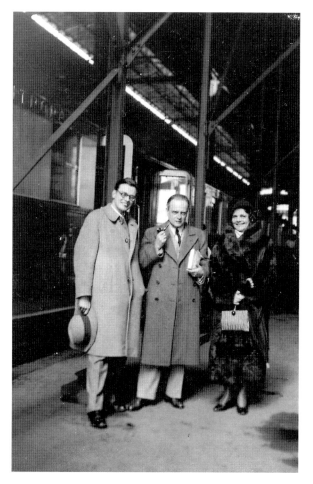

Klee with his son Felix and his daughter-in-law Efrossina at Basel SBB railway station, 12 April 1932.

colleagues, and even of his routine as a teacher. The latter may have involved obligations and responsibilities, but it did mean contact with young artists, which was an important source of stimulation. The dark mood that spread through his pictures at this time seems also to have affected his immune system. For in the same year he fell seriously ill with a mysterious and above all incurable disease—sclerodermy, which causes a progressive drying and hardening of the mucous membranes, a disease that at the time was inevitably fatal.

The diagnosis was shattering. His work stagnated, with only 25 items being recorded in his personal catalogue for 1936. Twice that summer Klee went for treatment. Though he mentioned the illness only marginally in his letters to Lily, the imminence of death crippled him. Yet in time he seems to have decided to defy fate. From somewhere deep inside he found new vigor. As the years went on, his output grew, so that it soon surpassed the volume of work he had produced previously. His style changed as well. Cryptic runes appeared on colorful, gesturally painted color fields. In some cases, they have an objective, symbolic quality, but most of them lead a wholly abstract formal existence that, like Egyptian hieroglyphs, defy us to interpret them. This new sign language developed particularly in his graphic works, which Klee returned to with the enthusiasm of his early years as an artist. Among the most impressive products of these late years are his various angels, which accompanied him through this difficult time like guardian spirits he

Paul Klee in Bern, already visibly marked by his illness, 1939.

had conjured up from the depths of his troubled psyche.

In 1939, Klee applied for Swiss citizenship once again, but the Swiss authorities failed to come to a decision. He remained German against his will, meantime featuring in his "homeland" on the "degenerate art" list. Reservations about his work became more evident in Switzerland as modern art became increasingly associated with the left wing, and modern artists such as Klee and Hans Arp were regarded with deep suspicion. The police gathered secret reports producing the same kind of accusations as were made in Germany: his work was "degenerate" and would drive him mad, it was promoted by Jewish dealers for purely financial reasons, and displayed a "deterioration of good taste and the healthy ideas of the public."

"The Klee Case" was put on the agenda as the closing item to be voted on at the meeting of Bern Council on 5 July 1940. That day never came for Klee. He died on 29 June without his last wish to "be a citizen of this city" being fulfilled.

In a speech at the memorial service for Paul Klee in Bern on 5 July 1940, Georg Schmidt forecast the future apotheosis of Klee's art: "Spanish artist Pablo Picasso is the hugely vital driving force among the important artists of the present day, Dutch artist Piet Mondrian the most fundamental constructive force. But German artist Paul Klee, whom Swiss timidity

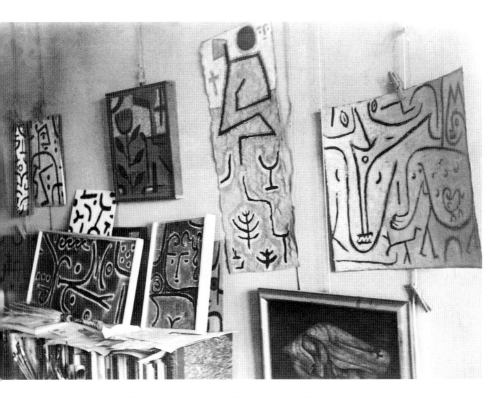

The studio at 6 Kistlerweg, Bern, March 1938, with pictures from the late oeuvre.

has deprived of one of his last wishes—to be able to die Swiss, and so deprived Switzerland of the fame of being able to claim him as its own under national law, Klee is the most reality-permeated among the few artists who can be considered the most important of our time. One day, we are profoundly convinced, the lightest voice of painter Paul Klee will turn out to be the most penetrating and most humane in the art of this age."

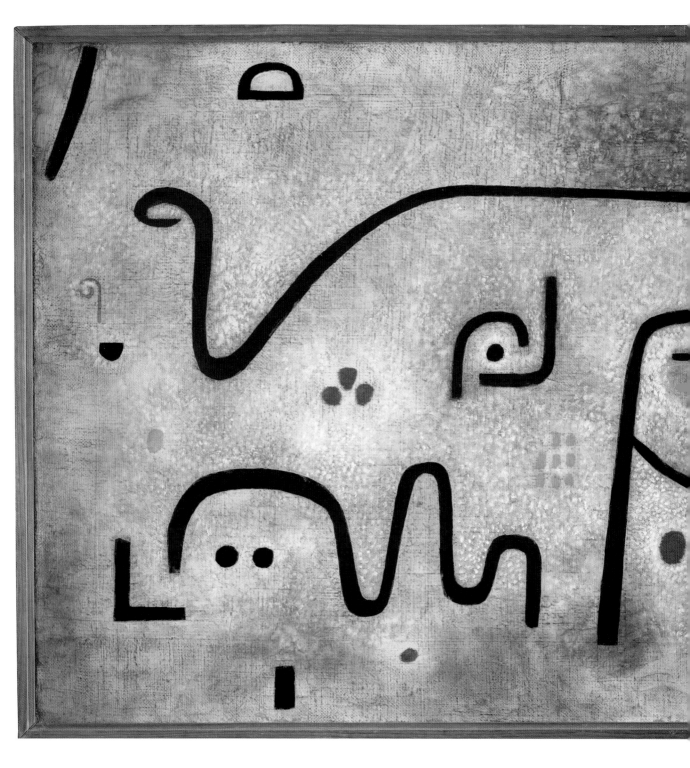

United contrasts In *Insula Dulcamara* (1938), Klee sought to unite in visual form contrasts that were rooted in the essence of nature. A face can be recognized in the middle of the picture that can symbolize both life and death. A line vaults from the left across the whole span of the picture in a melodious arch, resolving in a "chord" on the right. The abstract signs scattered around the picture indicate, among other things, elements such as earth, fire, water, and air.

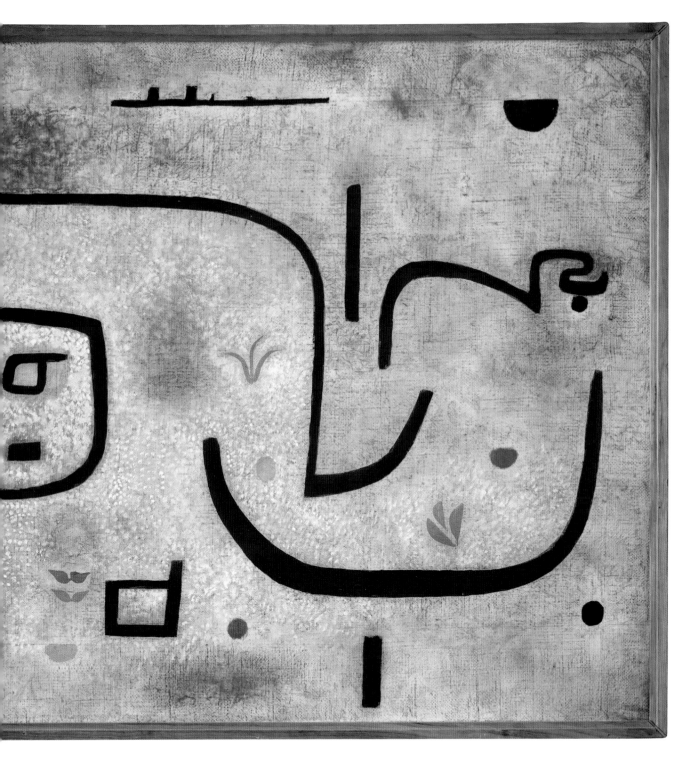

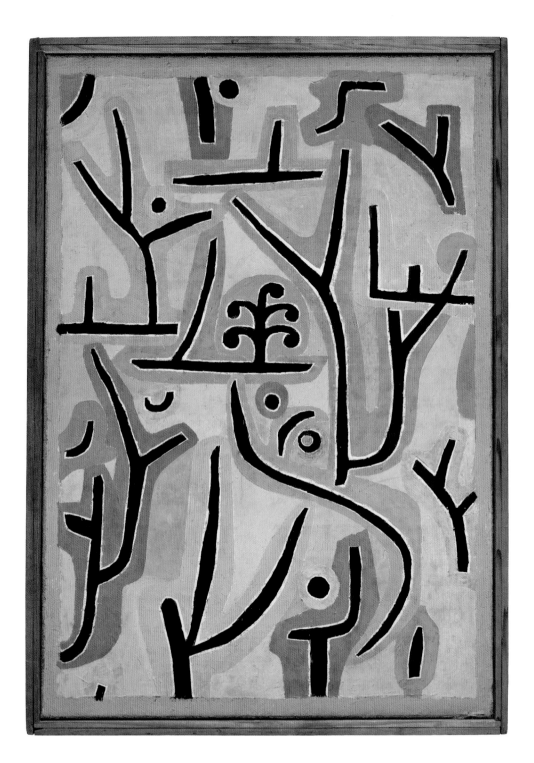

Musical symbolism The effect of *Park near Lu(cerne)* (1938) derives mainly from the strong contrast between the black signs and light background. Extensive branching shapes can be interpreted as basic plant forms or bar structures. These forms are surrounded by color zones that could allude to variegated foliage. But they could also be taken as colored aureoles emanating from rhythmic bifurcations.

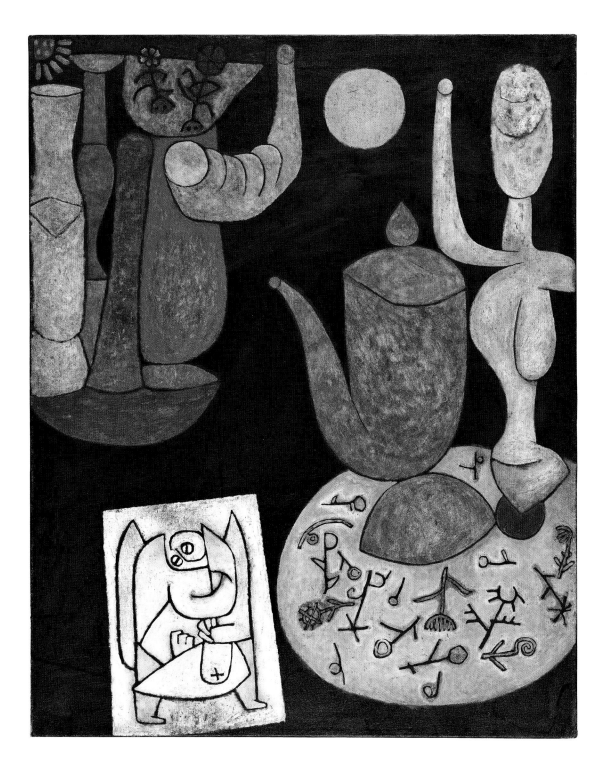

The enigma of a picture The enigmatic picture *Untitled (Still Life)* (1940) was still on the artist's easel when he died. Hieroglyphic signs are scattered beneath the still life. Bottom left, an angel image is intruding into the picture, and top left a remarkable bulging shape stands besides a sun. If you turn the picture round, you see on the top (then bottom) edge two plant-like shapes cycling on a tightrope.

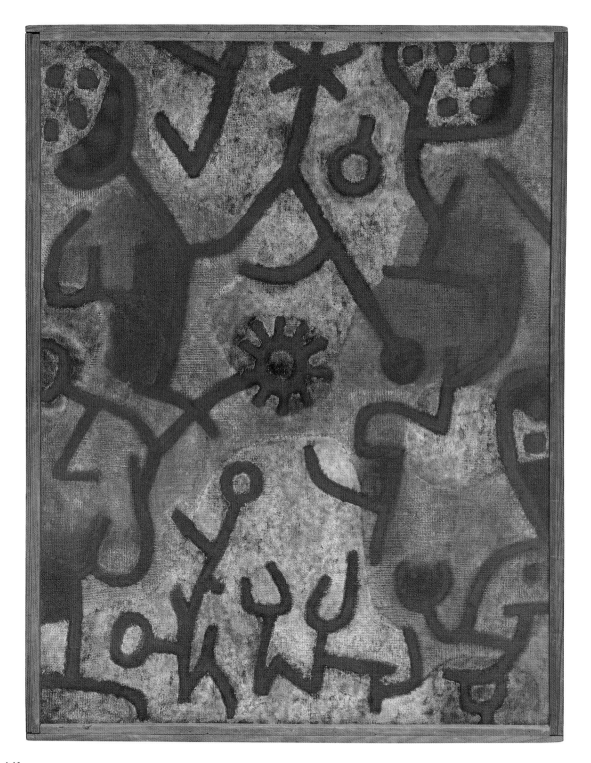

Life goes on In one of his last pictures, Klee puts across a message of reconciliation. In *Flora di Roccia* (1940) shows a botanical paradise flowering amid the chaos of wartime. New life unfolds in the heavy, beam-like symbols—hope of a better future.

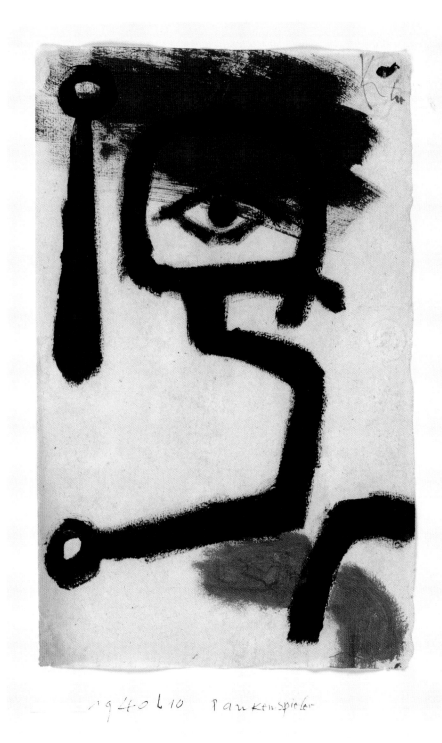

Vision With just a few strokes, Klee creates powerful visionary picture. Like Chronos, the *Drummer* (1940) determines the measure and course of time. Our eye turns the movements of the individual elements into a chronological sequence, generating a rhythmic alternation between concentrated immobility and forceful movement.

Love

"A small card index of all
the lovers I never had is a
mocking reminder of the
great issue of sex."

Paul Klee

For Klee, the discovery of sex ...

... went hand in hand with the traditional separation between the "higher" (love) and "lower" (sex). Parallel to acquiring experience of sex among Munich's free spirits, he also conducted a "decent," bourgeois relationship with Lily Stumpf meantime, marrying her only after concealing their relationship for years.

Morality Around 1900

At the time, bourgeois notions of morality also applied to artists, particularly to Klee, who had come to Munich from a very strict and sheltered home. Complying with these notions meant mainly going to concerts and the opera and domestic music making, during which he also got to know his later wife Lily Stumpf. But behind the bourgeois façade, Klee did not scruple to venture out into Munich's bohemian nightlife and there make acquaintances of an earthier kind.

The permissive sexual life among the bohemian art world had of course its downside. Venereal disease, illicit abortions, romantic suicides, and unacknowledged illegitimate children were not uncommon in artistic circles. The unsociable Cézanne kept his relationship with Hortense Fiquet, a former model, and even the birth of his son Paul, secret from his strict father to the day his father died.

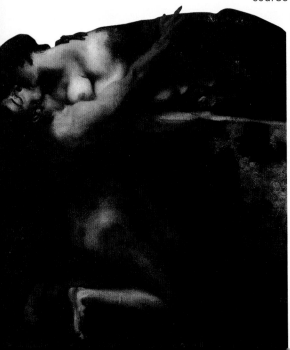

Considered indecent:
Franz von Stuck's
Kiss of the Sphinx (1898).

A desire to challenge bourgeois double standards ...

-→ ...underlay the vibrant sensuality of Wagner's musical drama.

-→ ...prompted artist Franz von Stuck to paint mainly erotic mythical creatures.

-→ ...lay behind Art Nouveau's interest in images of growth and creation.

Strict Censorship

Particularly in Bavaria around the turn of the century, a bigoted atmosphere prevailed under the cover of clerical cultural conservatism. Even visual sensuality in periodicals and posters was harshly prosecuted. For example, individual issues of the magazine *Simplicissimus* were confiscated and pulped, while writers such as Oskar Panizza and Ludwig Thoma were arrested for "offending public decency."

Even well-established artists such as Franz von Stuck were in the firing line of the moralists. A photograph of Stuck's painting *Kiss of the Sphinx*, for instance, had to be removed from an art dealer's window on police instructions. The public was likewise outraged when the scandalous relationship between Ludwig I of Bavaria and the dancer Lola Montez became public knowledge (right).

Prostitutes and Brothels

Despite these attempts to uphold public decency, citizens could always indulge their unspoken desires in numerous brothels and cheap hotels.

Alongside the registered establishments there were also countless "secret" (and of course illegal) sex establishments where vice blossomed. How hypocritical the prevailing morality was is clear from the outrage caused by Édouard Manet's *Olympia* (above) when it was exhibited at the Salon in Paris in 1863. The "shameless" woman lying naked on a couch and looking fearlessly at the viewer as she is brought a bouquet from an admirer, shows very explicitly a scene which would be all too familiar (from personal experience) to many an art connoisseur.

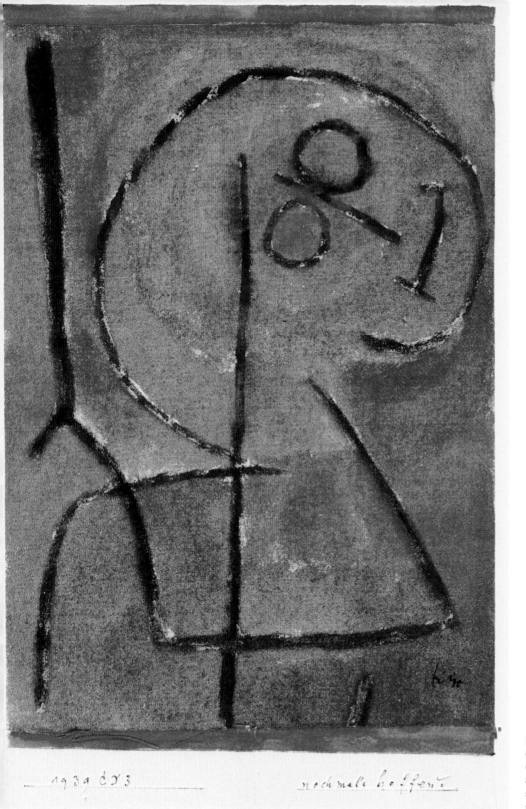

1939 cx3 nochmals hoffen

In Klee's last pictures, including *Still Hoping* of 1939, existential feelings such as fear, sorrow, and anger surfaced as his illness steadily worsened.

Lily Stumpf, Paul Klee's future wife, in Oberhofen by Lake Thun in 1904.

The Artist as Househusband

Klee's private life was totally devoid of both glamour and scandal. In fact, he adopted the cover of a solid middle-class life so to be able to work in tranquility. In all his artistic ventures, he maintained close contact with his family. Klee seems to have been the perfect example of Freud's notion of art as the sublimation of psychic (and particularly libidinal) urges.

Love in Munich

In his letters to his family, Klee gives a detailed account of his life as a student in Munich. This even includes itemizing his monetary affairs. In those years life seems to have consisted mainly of studying at Knirr's, his own private studies, and visits to museums, concerts and the opera. The nocturnal side features in just a few diary entries, though obliquely, since all diary entries were subsequently revised: "Other things, basic issues of life, became more important than the glory of going to Knirr's. Occasionally I

> **"Klee is the finest well-known modern spirit. ... He can reveal his entire wisdom with the barest line. That's how a Buddha draws."**
>
> **Oskar Schlemmer**

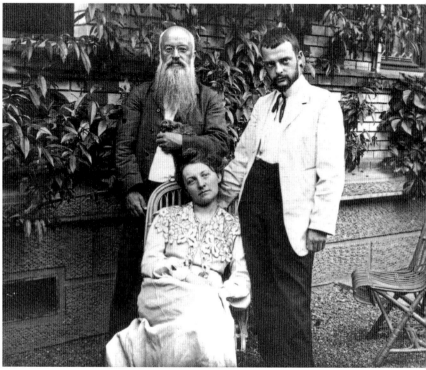

played truant ... In short, the first priority was to become a person, and the art would then follow from that. And that of course included relationships with women."

In his studies, which embraced (almost) all fields of human knowledge, Klee wanted to get to the heart of things. Work on his personality, of course, came first, and this led the young Klee to peer into the depths of the human soul: "Inspection of myself, right there in front of me, disengaged from literature and music. My efforts to acquire a refinement of sexual experience given up in that one particular case. Art I hardly ever think of, I just want to work on my personality. I have to be systematic about that and avoid any discussion. It is then very likely that some form of artistic expression will come out of it. A small card index of all of the lovers I never had is a mocking reminder of the great issue of sex."

In December 1899, during a musical evening at the house of friends of his parents, he made the acquaintance of pianist Lily Stumpf (1876–1946). The relationship was initially platonic, consisting mainly of making music (Lily playing the piano, Klee the violin), and of going to concerts together. In accordance with the prevailing double morality of the time, Klee also pursued relationships with women of the "lower classes" meantime. One of these affairs produced a son in November 1900, though the infant survived only a few weeks. Basically Klee was conforming with bourgeois conventions in letting the "serious" affair ripen slowly

while at the same time seeking sexual experiences with other women (mostly life-study models and barmaids). In this split between "higher" and "lower" love, Klee was in no way different from most men of his time: "The thing was just as I liked it. Cenzi didn't want any declarations of love, and even addressed me formally as *Sie*. I used the familiar *du*, and always found her a steady, sensible creature. No trace of commonness."

Lily Stumpf

The musical collaboration finally blossomed into love, a six-year engagement, and a 34-year marriage in which Lily stuck by Paul Klee through thick and thin with the courage of a lion.

Lily Stumpf was a remarkable woman with great charisma and a clear gaze that radiated strength and trust. When she lost her mother, Annemarie Stumpf, née Pohle, at the age of 16, her father, medical health officer Dr Ludwig Stumpf from Munich, re-married. Sadly, Lily's stepmother, Marie Schneider, who was not much older than Lily, was racked by jealousy, and so made a hell of the lives of Lily and her sister Marianne.

A match with an unemployed artist was of course out of the question in such a household, which is why Lily and Paul had to meet secretly for a long time. One place they could meet was the family holiday home in Bad Wiessee on Lake Tegernsee. In June 1900, they celebrated a secret engagement on the Wallberg (mountain) south of the lake. Klee then set off immediately on a lengthy trip to Paris to clarify his feelings in his own mind before he returned to his parents in Bern and "confessed" his love for Lily.

Paul and Lily finally married in Bern on 15 September 1906. The connection with Lily's parents was subsequently broken off for 12 years. Eventually, her father disinherited Lily, but when he died in 1923 his estate was worthless anyway because of inflation. Lily had thus lost nothing and was now free of nagging parental disapproval. She had had her way, had asserted her love for Paul, and had embarked with him on an uncertain future.

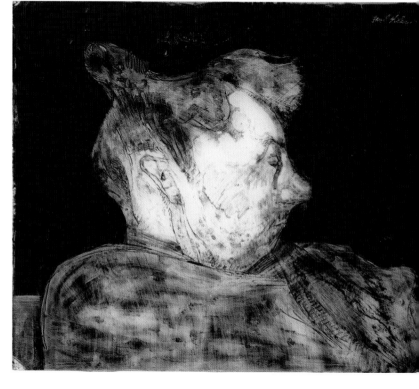

Pregnancy (1907) is a painting on glass. Klee gives the portrait of his pregnant wife an openness that neither touches up nor grotesquely distorts anything.

Domestic Arrangements

There was a profound change in Klee's life on 15 September 1906. Under entry 778 in his diary, he writes: "I am a married man, because I've been through the door for married couples at the registry office in Bern. Herr Henzi delivered some sonorous exhortations, first to the left, then over a large bouquet on the right, then to me, then turning to my bride, as she was then. It happened to be market day in the cathedral market, and the butchers sniggered when we walked past their stalls. That's the way the popular mind was."

They moved into a small, modest three-room apartment on the second floor of 32, Ainmillerstrasse, at the back of an apartment block. Lily was the breadwinner, giving piano lessons. Klee ran the household and cooked. Later, he minded the children as well. This division of labor would go on for years, during which time Lily also had several prolonged spells in a sanatorium. Klee faithfully kept her up-to-date with the latest news, writing letters to her every day. The constant stream of reproaches from Lily's father infuriated him, but it was a fact that Klee could contribute little to the family income because he had not yet started to earn with his art.

Contact with Lily's family was finally broken off following a sharp letter from Klee in September 1907 objecting to (among other things) any interference in their lives: "I advise you to desist from any notions of a reconciliation 'with conditions,' and to drop these

Lily and Felix Klee
in Munich, 1908.

edifying admonitions and attitudes. Life provides us with enough edification now. Everything past is so irrelevant that I shall forgo any further contact."

In November 1907, their son Felix was born. Klee became a solicitous father and diligent househusband. In a special "Felix diary," he wrote detailed notes about the development of the child, like this remark about language development: "Says *ólly-yólly-yólly tógedo, tógedodó, todgedo* (are teething and language development connected in some way?)."

Klee seems to have almost entirely taken over raising the infant. He likewise had to cope single-handedly with the severe illness that afflicted Felix from February to May 1909 and could be overcome only by an operation. Klee documented the course of the illness in great detail, recording in the diary every day the progress of the fever, visits by doctors, and the medicines they prescribed. Once Felix was finally out of danger, Paul summed up in his diary: "It is at any rate clear from these lines alone that this illness had us all holding our breath. I took over all the nursing, only at the worst time did I allow to nurse to take over at night. Olga Lotmar also helped me quite often in a very proper manner as a doctor." This division of labor was unusual for the time and no doubt gave rise to amusement in such a conservative environment, but that does not seem to have troubled Klee. Perhaps being with Felix every day in the first years helped his understanding of children's drawings and so influenced his own stylistic development—as seen, for example, in his "stick men" illustrations to *Candide* (page 36).

Devoted father Paul Klee built his son Felix an imaginative puppet theater and made numerous glove puppets for it.

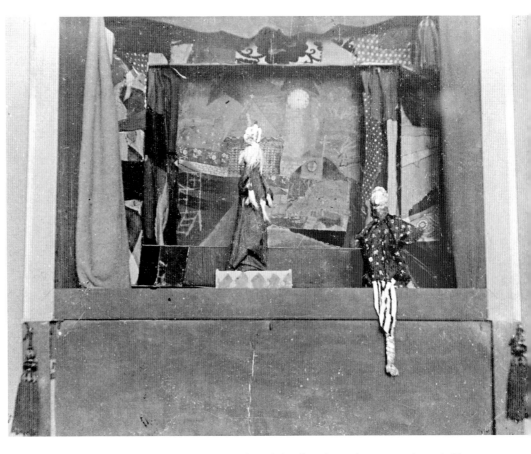

The finest expression of the father-son relationship is the glove puppet theater that Klee built for Felix. The 50 or so puppet figures included well-known characters not just from fairy tales but also from opera. One of the figures represents Klee himself (above, and page 107). Father and son remained very close over the years. When the family moved to Weimar, 14-year-old Felix went with them and became the youngest (and cheekiest) pupil at the Bauhaus.

His Son's Memoirs

Despite a demanding teaching program and other obligations at the Bauhaus, Klee still found enough time for his son. In his memoirs, Felix describes the walks father and son generally took together on the way to work, their path leading through a romantic park. Here, Klee caught his son's attention with vivid observations about nature, especially about birds and flowers.

Even after the move to Dessau, these joint walks and trips to the surrounding districts still remained a welcome change from the Bauhaus routine, and reinforced the close bond between father and son, which endured until Klee's death in 1940. Felix remembers: "We discovered a real miracle of gardening in Wörlitz, only half an hour away. The Old Dessauer [Leopold I, 1676–1747] laid out the park, and not a month passed in which Klee did not stroll between the Temple of Flora

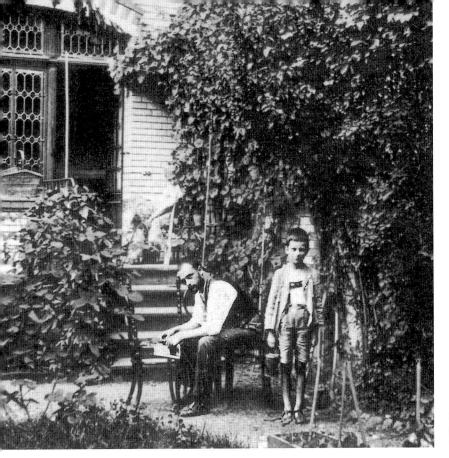

Paul and Felix Klee in Bern,
summer 1914. Klee's mother,
Ida, is in the background.

and the rocks for climbers, and the artificial Vesuvius.
My father felt very happy in his new 'four large walls.'
Here his work could be systematically developed to-
wards perfection ..."

Felix Klee finishes his memoirs with a glance at
Klee's tomb, thinking back to the happy days of child-
hood: "When we go for a walk to the parents' grave
on lovely autumn day like this, in the rural tranquility
of Schlosshalden cemetery I remember the utterly
happy days of my own childhood. Yellow and white
asters, begonias and roses have been planted around
my father's urn. The inscription on the large tomb-
stone reads:

I am not fathomable at all in the here and now,
Since I live just as well with the dead
As with the unborn,
Somewhat nearer the heart of creation than normal,
But still nowhere near close enough.

Bizarre Klee distilled his sexual curiosity in grotesque scenes such as the *First Version of Woman and Animal* (1903).

Hidden temptation *Girl with Pitchers* (1910) is generally taken as proof of Klee's passing interest in Picasso and Cubism. But does it not also show erotic tension, reinforced by the round, swollen vessels suggesting woman's breasts and the woman's sideways glance?

Rare portrait The subject of *Portrait of a Child* of 1908 was Klee's little son, Felix.

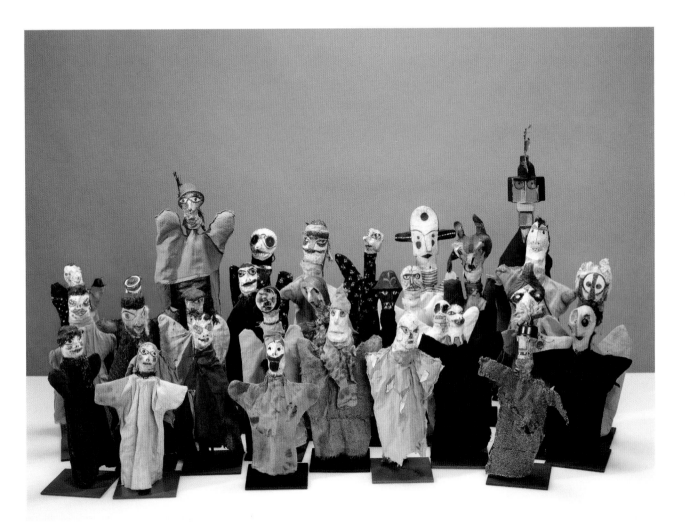

Klee's collection of dolls Klee's handmade glove puppets were not only based on well-known fairytale figures but also included an arsenal of expressive heads that appear to have come from his pictures. There is even a Paul Klee figure among them (left)!

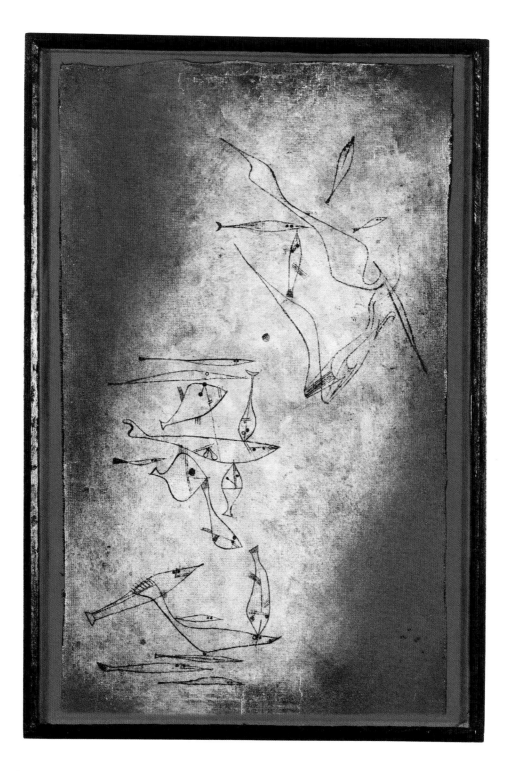

Fish magic The fish was particularly symbolic for Klee. He used its scaly exterior to explain the difference between "indivisible" and "divisible" structures. In *Fish Picture* (1925), the main effect however is the ocean of deep blue color, where fish feature in various forms. The picture is also a fine example of the combination of different techniques.

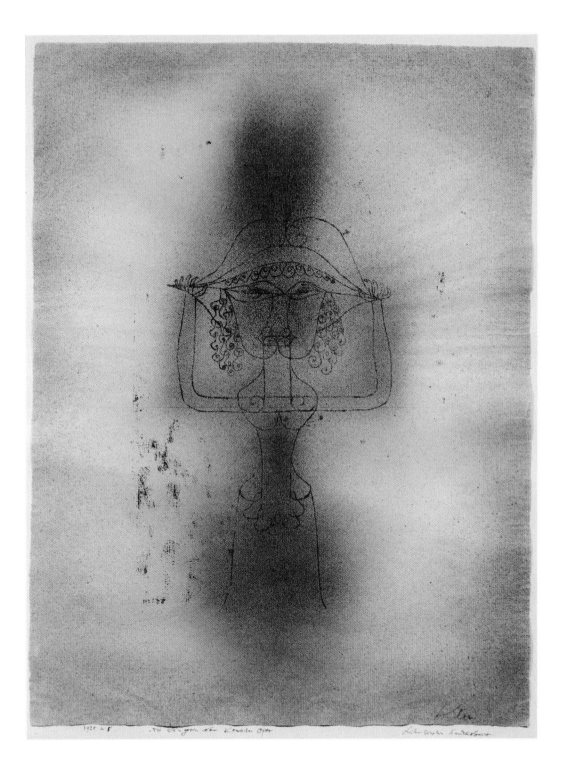

In the mask of myth *The Singer of the Comic Opera* (1925) is the last in a series of scenes inspired by the figure of Fiordigli in Mozart's opera *Cosi Fan Tutte*. Klee depicts Fiordigli with the tricorne of her lover, whom she has followed into battle so as to be safe from further temptations. Here, the operatic figure has become detached from the theatrical context to become a mythical figure of the "eternal woman."

Klee Today

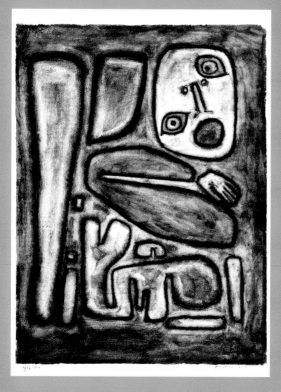

"... one worked hard; but genius isn't hard work, though an utterly fallacious cliché thinks it is. genius is not even partly hard work because maybe geniuses were also hard workers. genius is genius, a gift, without beginning and end. is begetting."

Paul Klee

The influence of Klee ...

... is difficult to assess. His oeuvre is large and multi-faceted, and still has to be fully explored and interpreted. It displays too many different approaches for us to really talk about a single, easily identified style that other artists could simply follow. Even so, Klee's work is not simply to be consigned to history, a milestone in the development of modernism. It is a beacon that shines far into the future.

Klee's Theoretical Writings

Klee's extensive theoretical writings were first published by Jürg Spiller in the 1950s (translated by the 1960s). This compilation of notes from Klee's teaching, lectures, and manuscripts was certainly serviceable as a start, but from a critical point of view it had the disadvantage of being unhistorical and very subjective. Amassing pictures from all his periods as evidence of Klee's various pronouncements on art, together with inaccurate quotations of original texts, makes the publication disappointing. By contrast, recent publications of his theoretical writings has tried to do justice to Klee's own precision of critical thought.

The Gift of Livia Klee

As part of the fundamental decision by the Klee family to make the works in their private collection available to a broad public, Klee's daughter-in-law Livia Klee-Meyer took the decisive step of leaving her share of the estate, a total of 681 works, to the city and canton of Bern. A condition of the bequest was that a Paul Klee Museum be built by the end of 2006. This condition was fulfilled with the opening of the Zentrum Paul Klee in 2005.

The Paul Klee Center

The Paul Klee Center in Bern is not simply a new Klee museum but an international cultural center entirely in keeping with Klee's interdisciplinary interests. In accordance with the original concept of its founder, Dr Maurice Miller, the Paul Klee Center is an international meeting place for researching and presenting Klee's works, and for studying its reception. It is at the same time a platform for cross-disciplinary forms of artistic expression. Architect Renzo Piano designed a spacious green island for the project, with the architecture standing out in the form of three undulations. The "landscape sculpture" thus arising marks out the Center from afar. Approximately 40%—in other words about 4,000 paintings, watercolors and drawings of the almost 10,000 works Klee executed—are on show. The Center's collection is the largest anywhere of a single artist of world standard.

Beneath Piano's three "hills" of steel and glass are the spacious exhibition areas, a music room, an events room, a children's museum with its own program, a multifunctional promenade area with numerous opportunities for visitors to meet and talk, plus conference rooms and seminar rooms for national and international conferences equipped with the most up-to-date infrastructure. Art, music, theater, dance, literature, art history and art education are thus not only brought close together but, by being in proximity, will be able to find new forms of expression through collaboration and interaction.

The Paul Klee Foundation

Shortly after the end of World War II, Klee's extensive estate was transferred to a foundation, as there was a danger of his work being dispersed by the Allies. The Klee Gesellschaft under Hermann Rupf deposited the estate temporarily in the Kunstmuseum in Bern. The aim in setting up the Foundation was to put together a collection of representative works from all Klee's creative periods, and to assemble an archive of the works and of the artist that could then be used for serious academic research.

Following the recognition of the Foundation by the artist's heir, Felix Klee, who was able to move to Bern from Germany only in 1948, the estate was divided up.

In early 1953, Felix Klee took the following works into his collection: 97 panel paintings, 414 colored drawings, 614 monochrome drawings, 4 small sculptures, 2 reliefs, 13 *verres églomisés* (paintings on glass), 41 prints, and 69 works by artists who were friends of Paul and Lily.

The Foundation's collection then comprised: 40 panel paintings, 163 colored drawings, 2,253 monochrome drawings, 10 sketchbooks, 11 sculptures, 28 *verres églomisés*, and 89 prints.

Besides these, the Foundation took over the entire "pedagogic estate" (approximately 3,000 drawings with Klee's teaching notes from the Bauhaus days), his diaries from 1898–1918, an exercise book of poems, and his writings on art theory.

This division of Klee's oeuvre was at the same time the start of the rediscovery and assessment of his artistic achievement. Since 1953, large parts of the Foundation's collection have been on show in the Kunstmuseum in Bern.

After the death of Felix Klee in August 1993, his collection passed into their hands of the joint heirs, Livia and Aljosha Klee. They too decided to place their collection in a museum that was exclusively dedicated to the work of Paul Klee.

On 1st January 2005, the Paul Klee Foundation became the Foundation Zentrum Paul Klee and continues to commit its efforts to the care and research of Klee's work.

The Paul Klee Center in Bern, an architectural
masterpiece by Renzo Piano, 2005.

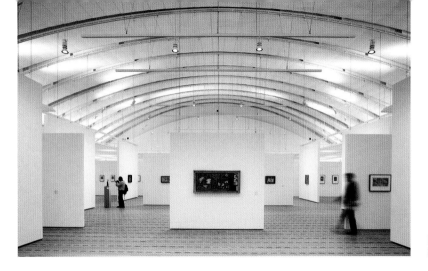

Interior view of the Paul
Klee Center in Bern.

Klee as an Inspiration

Klee was not interested in leaving a tidy and uniform stylistic legacy. What interested him was the complexity of life, art being an "allegory of Creation." To this end, he wove a great number of themes into polyphonic wholes of color and forms, figures and symbols, that seek to embrace the whole of life. It is thus possible to get an overview of only parts of the oeuvre, since what Klee's theory and practice have to offer us remain almost inexhaustible even today.

Klee and Wols

Even at a first glimpse, the influence of Klee's work on Wols (the German artist Alfred Otto Wolfgang Schulze, 1913–1951) as the fore-runner of Art Informel is obvious. Wols' delicate web of lines, which includes or at least hints at figurative elements, the underlay of colored spots in which constructive elements appear only to be negated, the merest hint of a visual frame for the picture, and the inclination towards fantasy in cosmic realms all suggest a knowledge of Klee's pictures, especially those from the Bauhaus period.

> **"Sometimes I dream of a work of great breadth covering the entire span of elements, representation, content and style."**
>
> **Paul Klee**

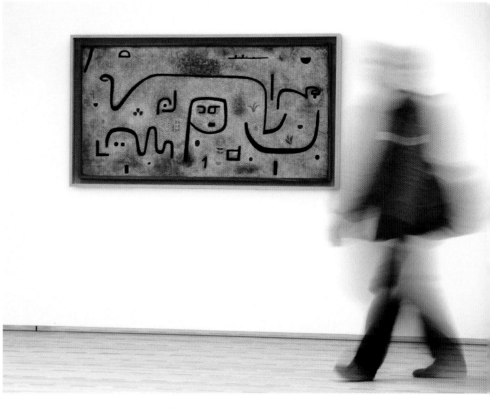

Klee's *Insula Dulcamara* (1938) at the Paul Klee Center, Bern, 2005.

Wols himself studied photography at the Bauhaus under László Moholy-Nagy, even if only briefly, but first came into contact with Klee's work when he went at a major international art exhibition in Dresden in 1927. Again, after Wols had settled in Paris in 1932 he had an opportunity to see several exhibitions of Klee, including one at the Galerie Colette Allendy, where Wols himself exhibited. Finally, a special issue of the journal *Cahiers d'Art* in 1945–1946, whose authors were in personal contact with Wols, examined Klee's life and work in some detail.

Even the first watercolors by Wols from 1932 display "dream scenes" and "psychic improvisations" in a Klee vein. Though Wols found inspiration and analogies in Klee's works, he adopted a diametrically different position: "Klee took dreams and thoughts to a degree of astonishing beauty. Wols in contrast performs his acrobatics on a steep slope where our little personal dramas don't particularly count. Where it's a matter of courtesy for common sense to fail, where the beautiful and the ugly become one."

Wols was also more interested in the dark side of life. Nothing in nature was repellent to him, and even ugliness was beautiful in its elementariness. Klee's quest was for a basic internal map of the visible: "You learn to seize things by the roots, you find out what flows underneath and discover the prehistory of the visible." Instead of copying nature,

the artist's task is to penetrate its deepest secrets and internal construction so as to put together his material, his subject matter and forms, and from that to make pictures. It was a view of art that Klee and Wols shared.

However, Wols went beyond Klee in drawing upon the unconscious: "Seeing means closing your eyes." His passive introspection and self-exploration contrast with Klee's active artistry working at the formal deciphering of the creative principle. Even so, the analogies in formal design and the related repertoires of subject matter are astonishing. Alongside dream, water and garden landscapes, cities, ships, bizarre creatures and anthropomorphic, erotic and floral forms such as frequently occur in Klee are likewise found in the watercolors and drawings of Wols, which were from the first very personal and autobiographical.

In Cassis after 1940, these associative, figurative references, which can easily be compared with similar motifs from Klee's work, gave way to a new view of nature: "In Cassis, the stones, fish and rocks I saw through a magnifying glass, the salt of the sea and the sky, put the importance of mankind out of my mind. They told me to turn away from the chaos of our hustle and bustle and showed me eternity in the small waves of the port that keep on coming without ever being the same."

For Wols, this development from 1940 of an "informal" approach resulted in the breaking up of representation. Abstracting the organism as a closed form, Wols then pushed on to a new dimension of reality based on an altered view of nature in which he was capable of feeling the unity of complex cosmic creation through things.

Wols drew much inspiration from the work and thought of Paul Klee—from the transparency of cosmic creation and the "global drama" to the liberation of creative gestures. The works he did in Cassis from

1940 were in this respect the first examples of a spontaneous kind of painting that heralded the painting of Art Informel, a gestural form of abstract art that flourished in Europe during the 1940s and 1950s.

Klee and the Theater

Klee's work is full of allusions to dance, the theater, and opera. He depicts operatic characters and circus scenes, and uses particular figures and elements of the theater such as clowns, marionettes and masks, which are constant components in his artistic repertoire. Over and above that, he uses theatrical terminology in his picture titles, placed stage curtains round landscape scenes, and presents human relationships in the form of theatrical settings. Many theatrical subjects were closely bound up with Klee's theoretical and philosophical musings, for example on the topic of circus performers in the context of Klee's theory of balance. For Klee, life was a *theatrum mundi*, the pictures were the stage on which life can be acted out again as transformed by artistic expression, on which Klee stamped his experience of the world and himself. Conversely, certain subjects that Klee invented for his own work can be found in present-day video art. No instance of direct influence can be involved here—it is really a matter of structural analogies. Klee trained his sharp eye on everyday situations and caricatured them to reveal aspects of interpersonal relationship. Similar ideas inform the work and procedures of Rosemarie Trockel (German), Cindy Sherman (American), Peter Campus (American), and Pipilotti Rist (Swiss).

Since the 1970s, William Wegman (American) has been recording on camera brief scenes involving his dog. Wegman leaves the dog to run the show, creating an animal theater such as Klee often produced in his comic drawings and pictures. Exemplary analogies with Klee's world are evident in Wegman's work—the pleasure in dry humor, the search for grotesque situations and masquerades, and a very human understanding of the situation depicted.

Wols translated Klee's "psychic improvisation" into gestural doodles.

Klee and Art Today

Klee had no pupils or successors in a literal sense, even though many students at the Bauhaus went to his classes. Even in the free painting classes introduced by Klee and Kandinsky from 1927, the only direct stylistic influences in students' work derive from Kandinsky. The same was true of Düsseldorf—none of the students involved took him as a direct model. Klee's teaching was open to all sorts of associations and styles. He did not indicate preference for any, or concentrate on any of them exclusively.

Despite the richness and variety of styles and personal approaches in the art of today, it would not be difficult to identify traces of Klee's visual world here and there, for example in the works of Jürgen Partenheimer or Norbert Prangenberg (both German). Yet more important than the superficial stylistic comparisons between Klee and the modern art world is the reference to the almost inexhaustible subject matter, ideas and theories that form the basis of Klee's work—and still inform and inspire artists in a wide variety of forms and guises.

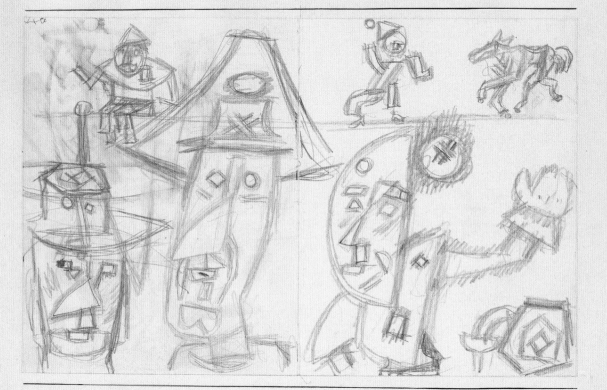

High wire of life A colorful company has assembled in the Big Top in *Circus Drama* (1926) acrobats, tightrope walkers and the clowns are all there. But co-ordination seems to be missing. The man on the tightrope seems about to fall off, and the expressions of the mask-like figures in the foreground display horror more than pleasure.

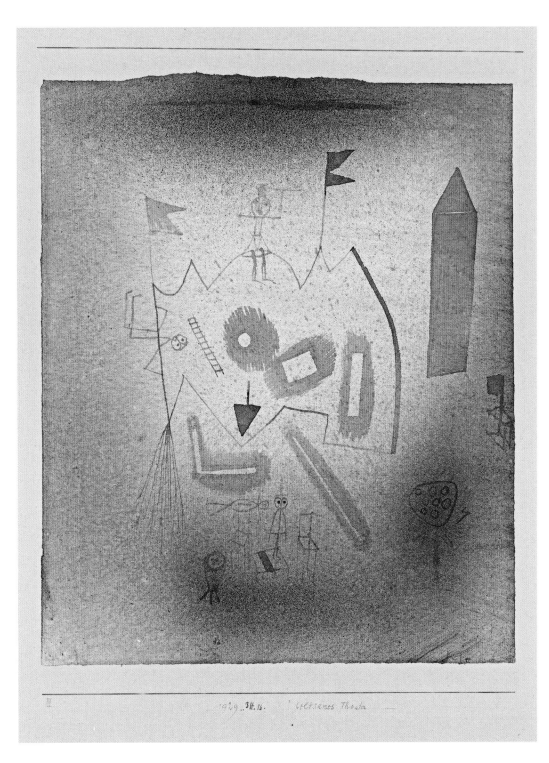

Theatrum mundi By contrast, in this image, *Strange Theater* (1929), the visual logic is clearer, though as usual the elements are open to various readings.

Game with masks Cindy Sherman comes up with a succession of new guises to show human masks and disguises, as in *Untitled #384*.

Uncalculated gestures Wols did not set out to show anything, but waited for the material itself or photographs of decay and decomposition to stimulate him. His style was intuitive and spontaneous. Instead of making a considered composition, he acted on the basis of rapid, spontaneous gestures. This work is entitled *Blue Grenade* (1946).

Picture list

p. 5: Logo of the Munich Secession.

p. 6: Franz von Stuck, *The Sin*, 1893, oil on canvas, Neue Pinakothek, Munich.

p. 7 top: Title page of the weekly magazine *Simplicissimus* (Munich), 19 April 1904.

p. 7 bottom: Music room, Villa Stuck, Munich.

p. 8: View of Odeonsplatz and Ludwigstrasse, Munich, photochrome, c. 1890/1900.

p. 9: Academy of Fine Arts, Munich, color print, c. 1905.

p. 10: Paul Klee, *Female Nude Taking Off a Blue Dress*, 1905, 10, pencil, tempera and watercolour on paper on card, 20.5 x 13.4 cm, private ownership Switzerland, on permanent loan to Paul Klee Center, Bern.

p. 11: Franz von Stuck, *Poster for the VII Internationale Kunstausstellung* in Munich, 1897, color print, 60 x 87.5 cm

p. 12: View of the *Blaue Reiter* exhibition.

p. 13: Cover of the *Blaue Reiter* almanac, 1912, watercolor over tracing/pencil, 27.9 x 21.9 cm, Städtische Galerie im Lenbachhaus, Munich.

p. 14: Wassily Kandinsky, *Gorge Improvisation*, 1914, oil on canvas, 110 x 110 cm, Städtische Galerie im Lenbachhaus, Munich

p. 15: Paul Klee, *Two Men Meet, Each Believing the Other to be of Higher Rank*, 1903, 5, etching, 11.7 x 22.4 cm, Paul Klee Center, Bern.

p. 17: Lyonel Feininger on his "Cleveland 100" in Berlin, 1898.

p. 18: Studio of Paul Klee, Schlösschen Suresnes, 1 Werneckstrasse, Munich, 1920, Paul Klee Center, Bern, gift of the Klee family, Bern.

p. 19 below: Eadweard Muybridge, *Animal Locomotion*, plate 616, 1887, photograph, 22 x 33 cm, Timothy Baum Collection, New York.

p. 19 above: Umberto Boccioni, *States of Mind I: The Farewells*, 1911, oil on canvas, 70.5 x 96.2 cm, Civica Galleria d'Arte Moderna, Milan.

p. 20: Paul Klee, *Carpet of Memory*, 1914, 193, oil on primed linen on cardboard. 37.8/37.5 x 49.3/50.3 cm, Paul Klee Center, Bern.

p. 21: Paul Klee, *Aged Phoenix*, 1905, etching, 25.7 x 18.7 cm, Museum of Modern Art, New York, Abby Aldrich Rockefeller Fund.

p. 22: Franz Marc, *Fighting Forms*, 1914, oil on canvas, 91 x 131.5 cm, Pinakothek der Moderne, Munich.

p. 23: Paul Klee, *Heavy Pathos*, 1915, 175, gouache and watercolor, 17.8 x 23.2 cm, Metropolitan Museum of Art, New York, Berggruen Klee Collection.

p. 24: Paul Klee's studio in Dessau, 1932.

p. 25: Arts Academy, Düsseldorf, c. 1930.

p. 26: Paul Klee, *Death for an Idea*, 1915, 1, lithograph, 15.6 x 8.6 cm, Paul Klee Center, Bern.

p. 27: Paul Klee, *Destruction and Hope*, 1916, 55, lithograph and watercolor, 40.5 x 33 cm, Paul Klee Center, Bern

p. 29: Paul Klee in Dresden.

p. 30: Paul Klee in his studio at the Staatliches Bauhaus, Weimar, 1924, Paul Klee Center, Bern, gift of the Klee family.

p. 31: Paul Klee, *Tale à la Hoffmann*, 1921, 123, color lithograph, 31.6 x 22.9 cm, Paul Klee Center, Bern.

p. 32: Paul Klee, *From Drawing 19/75 (Absorption)*, 1919, 113, watercoloured lithograph, 22.2 x 16 cm, Paul Klee Center, Bern, gift of Livia Klee

p. 33: Wasily Kandinsky and Paul Klee in the garden of their shared house at 6 Burgkühner Allee in Dessau, 1930.

p. 34: Paul Klee, *The Hero with a Wing*, 1905, 38, drypoint, 25.7 x 16 cm, Paul Klee Center, Bern.

p. 35: Paul Klee, *Fading Higher, Further*, 1919, 17, pen and ink on paper on cardboard, a) 24.3 x 9.2, b) 26.2 x 10.9 cm, Paul Klee Center, Bern.

p. 36: Paul Klee, *Illustration for Voltaire's Candide*, Chapter 9, *Il le perce d'outre en entre*, 1911, 62, pen on paper on card, 15 x 25.2 cm, Paul Klee Center, Bern

p. 37 left: Paul Klee, *Old Sound*, 1925, 236, oil on cardboard, 38.1 x 37.8 cm, Kunstmuseum, Basel, bequeathed by Richard Doetsch-Benziger 1960.

p. 37 right: Paul Klee, *Harmony in Blue = Orange*, 1923, 58, oil on black priming on paper, bordered in watercolor and pen, 37.3 x 26.4 cm, Rosengart Collection, Lucerne.

p. 38: Paul Klee, *Rhythmic, More Rigorous and Free*, 1930, 59, glue color on paper on cardboard, 47 x 61.5 cm, Städtische Galerie im Lenbachhaus, Munich.

p. 39: Paul Klee, *Angel, Still Groping*, 1939, 1193, crayon, distemper and watercolor on paper on cardboard, 29.4 x 20.8 cm, private collection, on deposit at the Paul Klee Center, Bern.

p. 40: Paul Klee, *Double Tent*, 1923, 114, watercolor and pencil on cardboard, 50.6 x 31.8 cm, Rosengart Collection, Lucerne.

p. 41: Paul Klee, *Eros*, 1923, 115, watercolor, gouache and pencil on paper on cardboard, 33.3 x 24.5 cm, Rosengart Collection, Lucerne.

p. 42: Paul Klee, *Monument in Fertile Country*, 1929, 41, watercolor and pencil on paper on cardboard, 45.7 x 30.8 cm, Paul Klee Center, Bern.

p. 43: Paul Klee, *Fire in the Evening*, 1929, 95, oil on cardboard; original frame, 33.8 x 33.4 cm, Museum of Modern Art, New York, Mr. and Mrs. Joachim Jean Aberbach Fund.

p. 44: Paul Klee, *Harmony of the Northern Flora*, 1927, 144 (E 4), oil on primed cardboard on plywood; original frame, 41 x 66/66.5 cm, Paul Klee Center, Bern, gift of Livia Klee.

p. 45: Paul Klee, *Glass Façade*, 1940, 288, wax paint on burlap on canvas, 71.3 x 95.7 cm, Paul Klee Center, Bern.

p. 46: Paul Klee, *Polyphony*, 1932, 273, oil and chalk on canvas, 66.5 x 106, Öffentliche Kunstsammlung, Basel, deposit Emanuel Hoffmann-Stiftung.

p. 47 top: Paul Klee, *Kinetic Variations*, 1931, 4 (4a), pen on paper on cardboard, 41.5/41.2 x 58 cm, Paul Klee Center, Bern.

p. 47 center: Paul Klee, *Kinetic Variations*, 1931, 4 (4b), pen on paper on cardboard, 34.5/34.9 x 55.7 cm, Paul Klee Center, Bern.

p. 47 bottom: Paul Klee, *Kinetic Variations*, 1931, 4 (4c), pen on paper on cardboard, 24.6/25 x 54.5 cm, Paul Klee Center, Bern.

p. 48 left: Paul Klee, *Castle in the Air*, 1922, 42, transfer drawing with oil and watercolor on priming on gauze and cardboard; original frame, 62.6 x 40.7 cm, Kunstmuseum, Bern, Hermann und Margit Rupf-Stiftung.

p. 48 right: Paul Klee, *Lying Awake*, 1932, 303, brush on paper on cardboard, 32.2 x 42.8 cm, Paul Klee Center, Bern.

p. 49: Paul Klee, *Legend of the Nile*, 1937, 215, pastel on cotton on glue color on burlap, 69 x 61 cm, Kunstmuseum, Bern, Hermann and Margit Rupf-Stiftung.

p. 50: Paul Klee, *Twittering Machine*, 1922, 151, transfer drawing with oil, ink, and watercolor on paper on board with gouache, ink, and pencil, 41.3 x 30.5 cm, Museum of Modern Art, New York, Mrs. John D. Rockefeller, Jr., Purchase Fund.

p. 51: Paul Klee, sketch for *Battle Scene from the Comic-Fantastic Opera "The Seafarer,"* 123, 1923, transfer drawing with oil, pencil, watercolor and gouache on paper on cardboard, 34.5 x 50 cm, Kupferstichkabinett, Kunstmuseum, Basel.

p. 52: Paul Klee, *Things Flowering*, 1934, 199, oil on priming on canvas, 81.5 x 80 cm, Kunstmuseum, Winterthur, bequest of Clara and Emil Friedrich-Jezler.

p. 53: Paul Klee, *New Harmony*, 1936, 24, oil on canvas, 93 x 66 cm, Solomon R. Guggenheim Museum, New York.

p. 54: Paul Klee, *The Light and the Sharpnesses*, 1935, 102, watercolor and pencil on paper on cardboard, 32 x 48 cm, Paul Klee Center, Bern.

p. 55: Paul Klee, *Ad Parnassum*, 1932, 274, oil and casein color on canvas; original frame, 100 x 126 cm, Kunstmuseum, Bern 1964, permanent loan from the Verein der Freunde des Kunstmuseums Bern.

p. 56: Paul Klee, *This Star Teaches Bending*, 1940, 344, glue paint on paper on card, 37.8 x 41.3 cm, Paul Klee Center, Bern, gift of Livia Klee

p. 57: Paul Klee, *Musician*, 1937, 197, watercolor on priming on paper on cardboard, 27.8 x 20.3 cm, Paul Klee Center, Bern, gift of Livia Klee.

p. 59: Paul Klee at the Bauhaus.

p. 60: Paul Cézanne, *Bridge over the Pool*, 1888–1890, oil on canvas, 64 x 79 cm, Pushkin Museum, Moscow.

p. 61 top: Paul Klee (l.) and Hermann Haller (r.), Villa Borghese, Rome, February 1902, photographer: Karl Schmoll von Eisenwerth, Paul Klee Center, Bern, gift of the Klee family.

p. 61 bottom: Quintet in the studio of Heinrich Knirr's painting and drawing school, Munich, Paul Klee on the right, 1900, Paul Klee Center, Bern, gift of the Klee family.

p. 62: Paul Klee in the garden of his father's home at 6 Obstbergweg, Bern, October 1908, Paul Klee Center, Bern, gift of the Klee family.

p. 63: Paul Klee, *Himself*, 1899, 1, pencil on paper on card, 13.7 x 11.3 cm, Paul Klee Center, Bern, gift of Livia Klee.

p. 64: Paul Klee, *Young Man, Resting*, 1911, 42, brush and pencil on paper on card, 13.8 x 20.2 cm, private ownership, Switzerland.

p. 65: Gabriele Münter, *Man in an Armchair (Paul Klee)*, 1913, oil on canvas, Pinakothek der Moderne, Munich.

p. 66: Wassily Kandinsky, *Study for Composition II*, 1910, oil on canvas, 97.5 x 130.5 cm, Solomon R. Guggenheim Museum, New York.

p. 67: August Macke, *Portrait of Paul Klee*, sketchbook no. 63, 1914, pencil, 15.6 x 10.4 cm, private collection.

p. 68 left: Paul Klee and August Macke on board of the *Carthage*, 1914.

p. 68 center: Paul Klee at the beach of St Germain, Tunis, 1914.

p. 68 right: Tunisian with camel, from August Macke's photo album, 1914. All three photos: Westfälisches Landesmuseum für Kunst und Kulturgeschichte, Münster.

p. 69: August Macke, *Kairouan I*, 1914, watercolor, 20.5 x 24.5 cm, Bayerische Staatsgemäldesammlungen, Munich.

p. 70: Paul Klee's squad, Landshut (Paul Klee standing second row in the center), summer 1916, Paul Klee Center, Bern, gift of the Klee family.

p. 71 left: Paul Klee in his studio, Weimar, 1925.

p. 71 right: The Bauhaus teachers in Dessau, left to right: Josef Albers, Hinnerk Scheper, Georg Muche, László Moholy-Nagy, Herbert Bayer, Joost Schmidt, Walter Gropius, Marcel Breuer, Wassily Kandinsky, Paul Klee, Lyonel Feininger, Gunta Stölzl, and Oskar Schlemmer, 1926, Felix Klee Archive.

p. 72: Paul Klee, *Moonrise at St Germain (Tunis)*, 1915, 242, watercolor and pencil on paper on cardboard, 18.4 x 17.2/17.5 cm, Museum Folkwang, Essen.

p. 73: Paul Klee, *In the Kairouan Style, Tempered*, 1914, 211, watercolor and pencil on paper on cardboard, 12.3 x 19.5 cm, Paul Klee Center, Bern.

p. 74: Paul Klee, *At the Gates of Kairouan*, 1914, 216, watercolor on paper on cardboard, 20.7 x 31.5 cm, Paul Klee Center, Bern.

p. 75: Paul Klee, *On a Motif from Hammamet*, 1914, 57, oil on cardboard, 26 x 21.5 cm, Öffentliche Kunstsammlung, Basel, gift of Richard Doetsch-Benziger.

p. 76: Paul Klee, *Landscape with Yellow Birds*, 1923–1932, watercolor and gouache on paper, 35.5 x 44 cm, private collection, Switzerland.

p. 77: Paul Klee, *Forest Berry*, 1921, 91, watercolor, 37.7 x 27 cm, Städtische Galerie im Lenbachhaus, Munich.

p. 78: Paul Klee, Wassily and Nina Kandinsky, Dessau-Wörlitz Park, May 1932, photo: Lily Klee. Paul Klee Center, Bern, gift of the Klee family.

p. 79: Wassily Kandinsky and Paul Klee in the pose of the Goethe-Schiller Memorial in Weimar, on the beach in Hendaye, France, August 1929, photo: Nina Kandinsky. Centre Georges Pompidou, Paris, Fonds Kandinsky.

p. 80: Paul Klee, *Beiträge zur Bildnerischen Formlehre* (Contributions to the Theory of Form), 1921–1923, pp. 112–113 of the original manuscript, Paul Klee Center, Bern.

p. 81: Paul Klee, 53 Am Horn, Weimar, 1 April 1925, photo: Felix Klee. Paul Klee Center, Bern, gift of Klee family.

p. 82: Paul Klee, *Order in Principle*, crayon, pencil and pen on paper, 27.5 x 20.7 cm, photo: Lily Klee. Paul Klee Center, Bern.

p. 83: Felix, Paul and Efrossina Klee, SBB railway station, Basel, 12 April 1932, Paul Klee Center, Bern, gift of the Klee family.

p. 84: Paul Klee in Bern, 1939, photo: Walter Henggeler, Keystone, Zürich.

p. 85: Paul Klee's studio, 6 Kistlerweg, Bern, March 1938, Grohmann-Archiv, no. 2615.

p. 86/87: Paul Klee, *Insula Dulcamara*, 1938, 481, oil and glue color on burlap; original frame, 88 x 176 cm, Paul Klee Center, Bern.

p. 88: Paul Klee, *Park near Lu(cerne)*, 1938, 129, oil and glue color on paper; original frame, 88 x 176 cm, Paul Klee Center, Bern.

p. 89: Paul Klee, *Untitled (Still Life)*, 1940, oil on canvas, 100 x 80.5 cm, Paul Klee Center, Bern, gift of Livia Klee.

p. 90: Paul Klee, *Flora di Roccia*, 1940, 343, oil and tempera on burlap; original frame, 90.7 x 70.5 cm, Kunstmuseum, Bern.

p. 91: Paul Klee, *Drummer*, 1940, 270, glue color on paper on cardboard, 34.6 x 21.2 cm, Paul Klee Center, Bern.

p. 93: Paul Klee in the "Latomia del Paradiso," Syracuse, Sicily, 1931, photo: Lily Klee, Paul Klee Center, gift of the Klee family.

p. 94: Franz von Stuck, *Kiss of the Sphinx*, 1898, oil on canvas, 160 x 144.8 cm, Szépmvészeti Múzeum, Budapest.

p. 95 bottom left: W.E. Vogel (after Josef Stieler), *Ludwig I of Bavaria*, 1841.

p. 95 bottom right: Josef Stieler, *Lola Montez*, 1847, from Ludwig I's "Schönheitengalerie" (Gallery of Beauties).

p. 95 top: Édouard Manet, *Olympia*, 1863, oil on canvas, 130.5 x 190 cm, Musée d'Orsay, Paris.

p. 96: Paul Klee, *Still Hoping*, 1939, 40.9 x 23.9 cm, Rosengart Collection, Lucerne.

p. 97: Paul Kee's future wife Lily Stumpf in Oberhofen by Lake Thun, 1904.

p. 98: Hans, Lily and Paul Klee in the garden at 6 Obstbergweg, Bern, September 1906, Paul Klee Center, Bern, gift of the Klee family.

p. 100: Paul Klee, *Pregnancy*, 1907, 19, *verre églomisé*, 27.5 x 32.8, Paul Klee Center, Bern, gift of Livia Klee.

p. 101: Lily and Felix Klee, Munich, 1908, Paul Klee Center, Bern, gift of the Klee family.

p. 102: Puppet theatre with two hand puppets: the Devil and Punchinello, 1916 (the puppets, frame and decoration were destroyed during an air raid in 1945), c. 1924, Paul Klee Center, Bern, gift of the Klee family.

p. 103: Ida, Paul and Felix Klee in the house of Paul Klee's father, Bern, summer 1914, photo: Mathilde Klee.

p. 104: Paul Klee, *First Version of Woman and Animal*, 1903, etching, 21.7 x 28.2 cm, Kunstmuseum, Bern, Hermann and Margit Rupf Foundation.

p. 105: Paul Klee, *Girl with Pitchers*, 1910, 120, oil on priming on cardboard, 35 x 28 cm, Paul Klee Center, Bern, gift of the Livia Klee.

p. 106: Paul Klee, *Portrait of a Child*, 1908, 64, watercolor on paper, 29.9 x 23.4/24.2 cm, Paul Klee Center, Bern, gift of Livia Klee.

p. 107: Group picture of 30 hand puppets, 1916-1925, Paul Klee Center, Bern, gift of Livia Klee.

p. 108: Paul Klee, *Fish Picture*, 1925, 60.5 x 40 cm, Rosengart Collection, Lucerne.

p. 109: Paul Klee, *The Singer of the Comic Opera*, 1925, 225, colored lithograph, 60 x 45.8 cm, Rosengart Collection, Lucerne.

p. 111: Paul Klee, *Spasm of Fear III*, 1939, 124, watercolor on priming on paper on cardboard, 63.5 x 48.1 cm, Paul Klee Center, Bern

p. 112: Paul Klee, pedagogical papers, *Statics and Dynamics*, manuscript of "Exacte Versuche im Bereich der Kunst," PN17a M20/51, pencil and pen on paper, 32.9 x 21 cm, Paul Klee Center, Bern.

p. 114: Paul Klee Center, Bern, exterior view (architect Renzo Piano), 2005.

p. 115: Paul Klee Center, Bern, interior view, 2005.

p. 116: Visitor in front of Paul Klee's painting *Insula Dulcamara* (1938), Paul Klee Center, Bern, 2005.

p. 118: Wols, *Picture*, 1944–1945, oil on canvas, 81 x 81.1 cm, Museum of Modern Art, New York.

p. 120: Paul Klee, *Circus Drama*, 1926, 184, pencil on paper on cardboard, 21 x 33.9 cm, Paul Klee Center, Bern.

p. 121: Paul Klee, *Strange Theater*, 1929, 316, pen and watercolor on paper on cardboard, 31.7 x 26.7 cm, Paul Klee Center, Bern.

p. 122: Cindy Sherman, *Untitled #384*, 1976/2000, black and white photograph, 25.4 x 20.3 cm, courtesy of the artist and Metro Pictures.

p. 123: Wols, *The Blue Grenade*, 1946, oil on canvas, 46 x 33 cm, Musée National d'Art Moderne, Centre Pompidou, Paris.

Cover:
Front cover: Paul Klee, *Fish Picture*, 1925, see p. 108
Back cover: Paul Klee at the Bauhaus, Weimar, 1925 (detail)
Outside front flap: Paul Klee in Dresden, 1925 (detail)
Inside front flap: (top row, l-r) Franz von Stuck, *Poster for the VII Internationale Kunstausstellung* in Munich, 1897, see p. 11; Eadweard Muybridge, Animal Locomotion, plate 616, 1887, see page 19 left; Wassily Kandinsky, Cover of the *Der Blaue Reiter* almanac, 1912, see p. 13; Franz Marc, *Fighting Forms*, 1914, see p. 22; Franz von Stuck, *The Sin*, 1893, see p. 6; (bottom row, l-r) Paul Klee (l) and Hermann Haller (r), Villa Borghese, Rome, February 1902, see p. 61 top; Lily and Felix Klee, Munich, 1908, see p. 101; Tunisian with camel, from August Macke's photo album, 1914, see p. 68 right; the Bauhaus teachers in Dessau, see p.71 right; Arts Academy, Düsseldorf, c. 1930, see p. 25; Paul Klee in Bern, 1939, see p. 84;

Inside back flap: (all works by Paul Klee): (top row, l-r) On a Motif from Hammamet, 1914, see p. 75; At the Gates of Kairouan, 1914, see p. 74; Moonrise at St Germain (Tunis), 1915, see p. 72; (middle row, l-r) Eros, 1923, see p. 41; Harmony in blue = Orange, 1923, see p. 37 right; Harmony of the Northern Flora, 1927, see p. 44; Fire in the Evening, 1929, see p. 43; Monument in Fertile Country, 1929, see p. 42; (bottom row, l-r) Still Hoping, 1939, see p. 96; Spasm of Fear III, 1939, see p. 111; This Star Teaches Bending, 1940, see p. 56; Untitled (Still Life), 1940, see p. 89;

If you want to know more…

Klee in his own words
- *Pedagogical Sketchbook*, Paul Klee, New York / Praeger, 1960.
- *Paul Klee: The Notebooks of Paul Klee, Vol. 1: The Thinking Eye*, ed. Jurg Spiller, New York / G. Wittenborn, 1961.
- *Paul Klee: His Life and Works in Documents Selected from Posthumous Writings and Unpublished Letters*, Felix Klee, New York / Braziller, 1962.
- *The Diaries of Paul Klee, 1889–1918*, ed. Felix Klee / University of California Press, 1968.
- *Paul Klee: The Notebooks of Paul Klee, Vol. 2: The Nature of Nature*, ed. Jurg Spiller, Woodstock, NY / Overlook Press, 1992.

Klee's life and works
- *Tunisian Watercolors and Drawings*, August Macke, Paul Klee, New York / Abrams, 1969.
- *Paul Klee and Primitive Art*, James Smith Pierce, New York / Garland, 1976.
- *Paul Klee: Figures and Faces*, Margaret Plant, London / Thames and Hudson, 1978.
- *Paul Klee: Legends of the Sign*, Rainer Crone and Joseph Leo Koerner, New York / Columbia University Press, 1991.
- *Paul Klee: His Work and Thought*, Marcel Franciscono, Chicago / University of Chicago Press, 1991.
- *Paul Klee*, Enric Jardi, New York / Rizzoli, 1991.
- *Of Angels, Things, and Death: Paul Klee's Last Paintings in Context*, Mark Luprecht, New York / Lang, 1999.
- *Paul Klee: Selected by Genius, 1917–1933*, Roland Doschka, Kunstmuseum Bern, Stadthalle Balingen, and others, Munich, New York / Prestel, 2001.
- *Paul Klee's Pictorial Writing*, Kathryn Porter Aichele, Cambridge / Cambridge University Press, 2002.
- *Paul Klee: Poet/Painter*, Kathryn Porter Aichele, Rochester, NY / Camden House, 2006.

Klee's graphic works
- *The Prints of Paul Klee*, James Thrall Soby, New York / Valentin, 1945.
- *Paul Klee Drawings*, Will Grohmann, New York / Abrams, 1960.
- *Klee Drawings: 60 Works*, Paul Klee, New York / Dover Publications, 1982.

Klee's puppets
- *Paul Klee: Hand Puppets*, Christine Hopfengart and others, Ostfildern, Germany / Hatje Cantz, 2006.

Klee and music
- *Paul Klee: Art & Music*, Andrew Kagan, Ithaca, NY / Cornell University Press, 1983.
- *Paul Klee: Painting and Music*, Hajo Düchting, Munich and New York / Prestel, 1997.

Klee and the Bauhaus
- *Paul Klee and the Bauhaus*, Christian Geelhaar, Greenwich / New York Graphic Society, 1973.
- *Teaching at the Bauhaus*, Rainer Wick, Ostfildern-Ruit, Germany / Hatje Cantz, 2000.

Klee and his contemporaries
- *The Blue Rider*, Hans Konrad Rothel; Stadtische Galerie Munchen and New York / Praeger, 1971.
- *The New Art of Color: The Writings of Robert and Sonia Delaunay*, ed. Arthur Allen Cohen, New York / Viking Press, 1978.
- *Klee and Kandinsky in Munich and at the Bauhaus*, Beeke Sell Tower, Ann Arbor / UMI Research Press, 1981.
- *Paul Klee and Cubism*, Jim M Jordan, Princeton / Princeton University Press, 1984.
- *Klee, Kandinsky, and the Thought of Their Time*, Mark W. Roskill, Urbana / University of Illinois Press, 1992.

Audio-visual material on Klee
- *Paul Klee: or, The Act of Creation*, Centre experimental de cinematographie, Film (English), New York / Film Images/Radim Films, 1964/1967.
- *Paul Klee: The Silence of the Angel*, Michael Gaumnitz and others, Institut national de l'audiovisuel (France), Video-recording/DVD video (English), Chicago / Arte Video (distributed by Facets Video), 2005.

Klee on the Internet
Paul Klee Center (Zentrum Paul Klee), Bern, Switzerland: http://www.paulkleezentrum.ch/ww/en/pub/web_root.cfm

Impressum

The pictures in this book were graciously made available by the museums and collections mentioned, or have been taken from the Publisher's archive with exception of:

Zentrum Paul Klee, Bern: pp. 10, 15, 20, 26, 27, 31, 32, 34, 35, 36, 39, 44, 45, 47, 48, 49, 54, 55, 56, 57, 73, 74, 78, 80, 82, 83, 85, 86/87, 88, 89, 90, 91, 100, 104, 106, 107, 108, 109, 111, 112, 120, 121

© Klee-Nachlassverwaltung, Bern: pp. 1, 18, 30, 61, 62, 70, 71 oben, 81, 93, 98, 101, 102

Rosengart Collection: pp. 37 right, 40, 41, 42, 51, 96

akg-images: pp. 8, 9, 29, 59, 114, 119

Artothek, Weilheim: pp. 13, 25

AP Photo/Keystone, Gaetan Bally: pp. 115, 116

Courtesy Cindy Sherman and Metro Pictures: p. 122

Bridgeman Art Library: p. 123

Editorial direction by Claudia Stäuble
Translated by Paul Aston, Rome
Copy-edited by Chris Murray, Crewe
Series editorial and design concept by Sybille Engels, engels zahm + partner
Cover, layout, and production by Wolfram Söll
Lithography by Reproline mediateam
Printed and bound by Stürtz GmbH, Würzburg

Printed in Germany on acid-free paper

ISBN 978-3-7913-4059-3

The Library of Congress Control Number: 2008935525

British Library Cataloguing-in-Publication Data: a catalogue record for this book is available from the British Library. The Deutsche Bibliothek holds a record of this publication in the Deutsche Nationalbibliografie; detailed bibliographical data can be found under: http://dnb.ddb.de

Prestel Verlag
Königinstrasse 9
80539 Munich
Tel. +49 (0) 89 24 29 08-300
Fax +49 (0) 89 24 29 08-335

Prestel Publishing Ltd.
4 Bloomsbury Place
London WC1A 2QA
Tel. +44 (0) 20 7323-5004
Fax +44 (0) 20 7636-8004

Prestel Publishing
900 Broadway. Suite 603
New York, N.Y. 10003
Tel. +1 (212) 995-2720
Fax +1 (212) 995-2733

www.prestel.com